The Coast of Maine

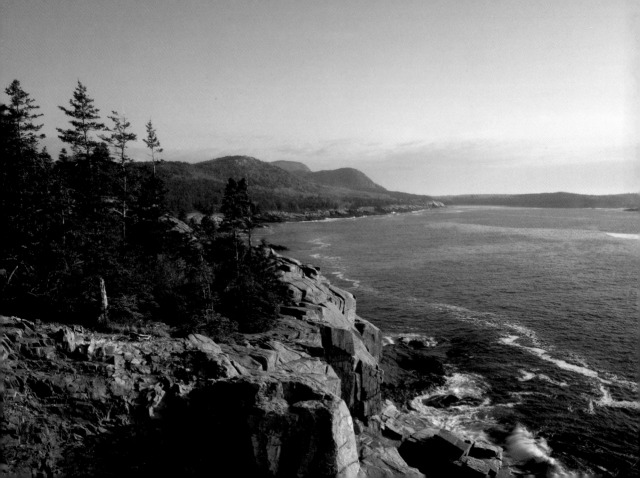

The Coast of Maine

CARL HEILMAN II

RIZZOLI
NEW YORK

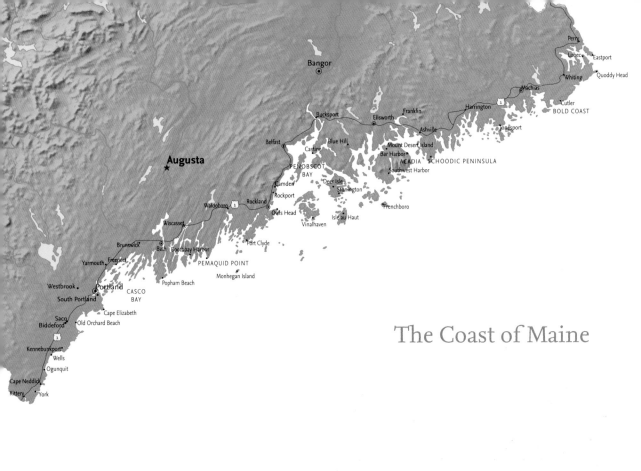

The Coast of Maine

Contents

frontispiece *Acadia National Park, looking east*
toward Sand Beach along the Ocean Path

Introduction

ON A WALL OF MY childhood home in Pennsylvania there was a framed lithograph that showed storm-driven waves crashing on a rocky shoreline. My parents told me it was a painting of the Maine coast. I grew up captivated by the wild energy of the wind-blown surf and rugged shore and dreamed of experiencing it all for myself.

My first visit to Maine was in 1976 when my sister, Mary Alice, and I drove to Acadia National Park during a college semester break. It was truly a classic winter that year with snow and ice covering the entire coastline. Temperatures went well below zero at night and barely made it above zero during the day.

Along the way to Acadia we stopped at Biddeford Pool and Fortunes Rocks for a day and also shopped at L.L. Bean's original two-story frame store. It was dark by the time we drove past the Bath Iron Works where crews were working on a ship that was docked by the huge crane. I'll never forget the vision of that huge shipyard—with industrial lights and the sparks from a welder's torch shining on the plates of ice surrounding the ship and floating down the Kennebec River.

We followed Route 1 through Ellsworth and made the turn to Bar Harbor at the light. At that time, the town ended around there. There were a few buildings and a gas station, but no shopping malls, chain motels, factory outlets, or big-box stores. We passed by the large satellite dish at the Ellsworth airport and then crossed the bridge to Mount Desert Island.

The Acadia we discovered was a beautiful and dramatic winter wonderland. Many of the bays were frozen over with slushy plates of ice. Icicles hung from the snow-covered cliffs and the spray from the surf froze almost on contact, coating rocks above the tide with a shiny layer of ice.

The park ranger we had found said, "Pick any site you like—there's no charge this time of year." The temperature dropped close to twenty-five below each night. By daybreak we'd be huddled deep in the downy depths of our sleeping bags—protected from the snow underneath by an insulating foam pad. There was one heated bathroom and no one else staying in Blackwoods campground at that time. At first light we'd be up and about, exploring as much as we could during our three days there.

We traveled around the island and went to Thunder Hole and Otter Cliffs, explored cliff-lined coves and cobblestone beaches, visited Bar Harbor and other quiet harbor villages, and watched the sun set at Bass Harbor Head Light. We climbed Gorham Mountain in evening twilight, and braved a bitterly cold morning at Sand Beach, watching the sun rise above the endless ocean while the misty waves curled one after another onto the sand and rocks with a soothing rhythm.

I return to the Maine coast often. While my wife, Meg, and I have made the Adirondacks our year-round home, we travel almost annually to Maine to relax and rejuvenate along the spectacular ocean landscape. Photographing for this book has given me the opportunity to explore much more of the coast and learn about the wonderful diversity of its residents, villages, and terrain.

There are many treasures along the Maine coast. In the latter part of June, lupines nod back and forth in the summer breeze. In August the annual blueberry crop is harvested from the sixty thousand acres of barrens that yield most of the country's wild blueberries. Throughout the summer and fall, almost ninety percent of the national supply of lobsters is caught along the Maine coast. Here, you will also find the nation's only nesting colonies of Atlantic puffins on a few select offshore islands.

It's only 278 miles on a direct route from Kittery, on the New Hampshire border, to the West Quoddy Head Light, at the easternmost point in the lower 48. However, this same area encompasses about 3,500 miles of convoluted shore-line—not including that of the 3,000 offshore islands. There are still more than sixty picturesque lighthouses that help make navigation safer in the unpredictable waters. Quaint villages lie around every bend of the coastline, home for the hardy year-round residents and summer visitors alike.

As increasing numbers of people continue to discover the special wonders of the Maine coast, there has been a corresponding increase in development that is fast encroaching upon the open spaces and natural habitats that make the area such a great attraction. Fortunately many organizations—among them the Audubon Society, The Nature Conservancy, the Boothbay Region Land Trust, the Maine Coast Heritage Trust, and many others associated with the Maine Land Trust Network—are working to maintain a healthy balance between human use and natural needs.

Upon arriving at the Maine coast, everyone seeks a personal retreat and creates special memories to take away. From the amusements and arcades of Old Orchard Beach to the pristine shores and wild forests of Acadia—the experiences to be enjoyed here are as diverse as the landscape itself. I feel fortunate to have explored so much of this special coastline and look forward to revisiting the Maine coast for many years to come.

—CARL HEILMAN II

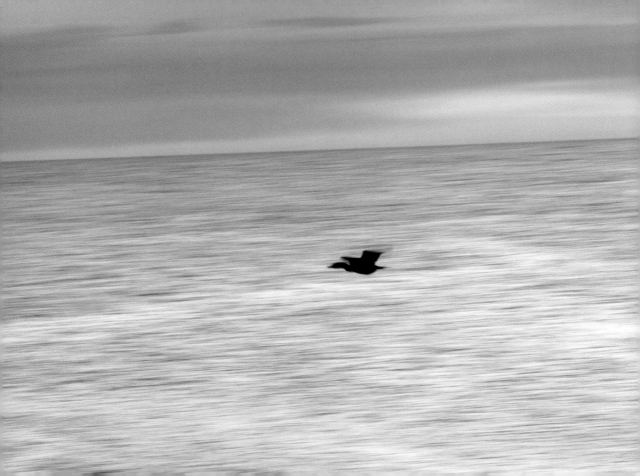

The Southern Coast Beaches and Byways

~ From Kittery to Freeport ~

York, Cape Neddick, Ogunquit, Wells, Kennebunkport, Biddeford Pool,

Old Orchard Beach, Portland Harbor

and the Casco Bay area

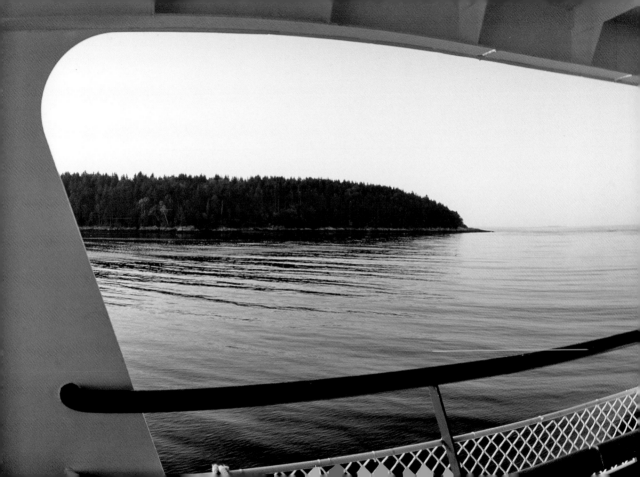

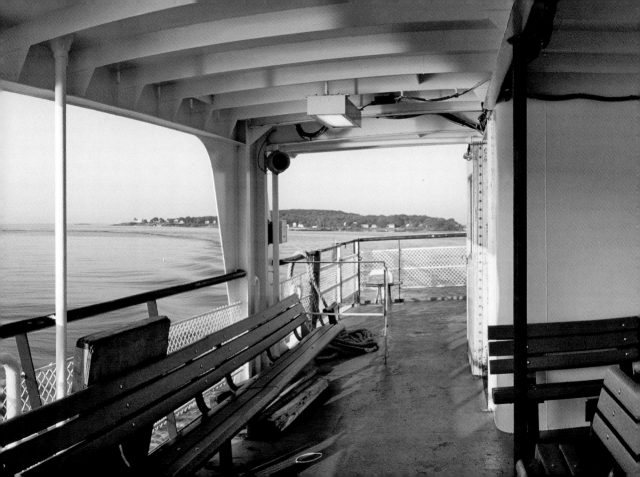

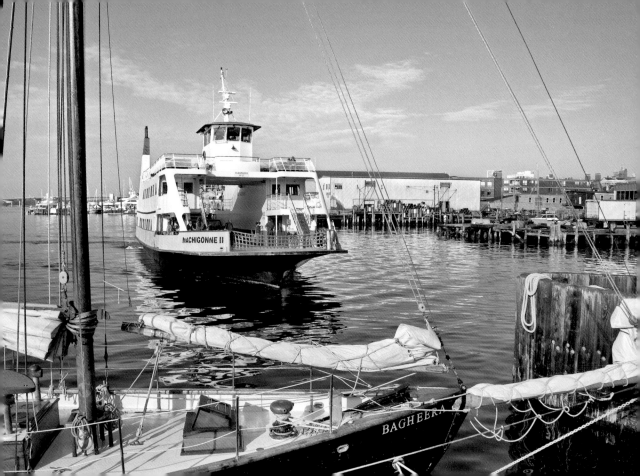

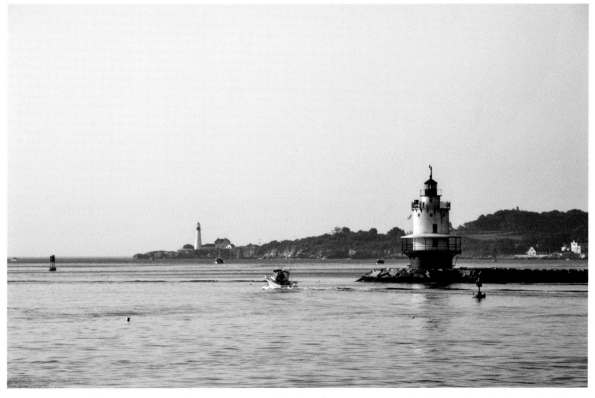

chapter opener *A duck flies over the ocean at the East Sanctuary, Biddeford Pool* previous page *Morning light over Casco Bay from onboard the early morning mail run ferry* opposite *The Peaks Island ferry maneuvers alongside the historic windjammer* Bagheera *at the Casco Bay Lines dock, Portland* above *Looking to the Spring Point Ledge Light and the Portland Head Light on Cape Elizabeth from the Casco Bay ferry*

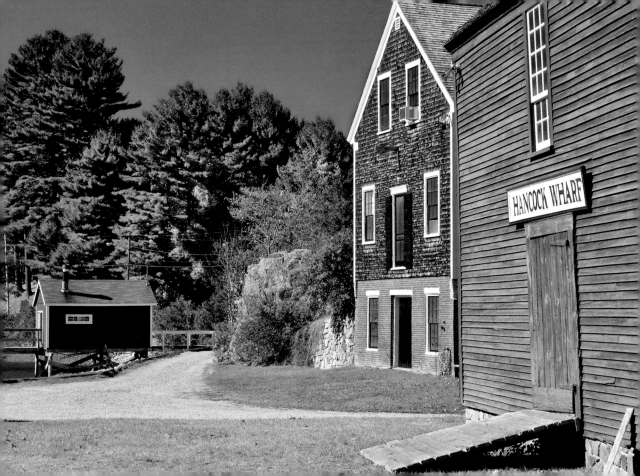

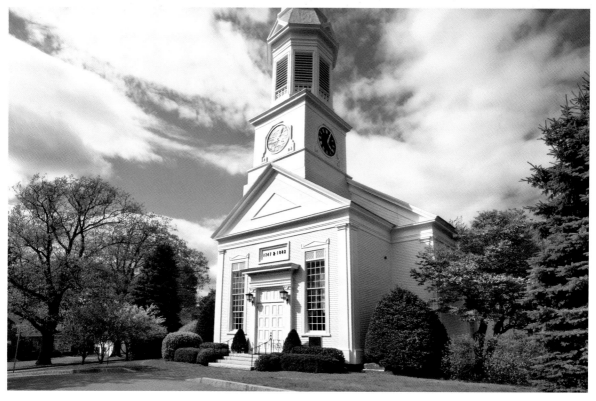

opposite *Once owned by John Hancock, this is the only remaining 18th-century warehouse in York*

above *The First Parish Church in York, a classic New England meetinghouse, was built in 1747*

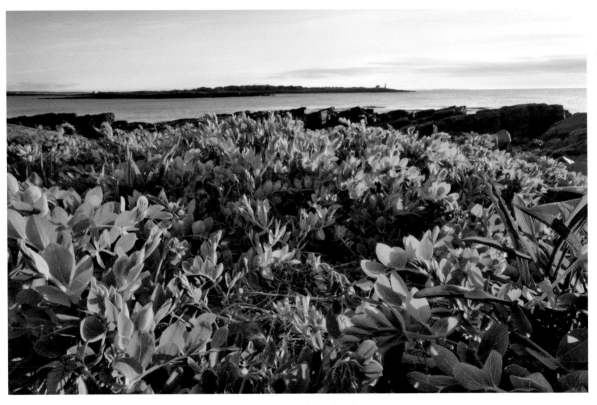

above *Sweet pea blooming along the shore of the East Sanctuary at Biddeford Pool*
opposite *Gay wings,* Polygala paucifolia, *in bloom at the Rachel Carson National Wildlife Refuge*

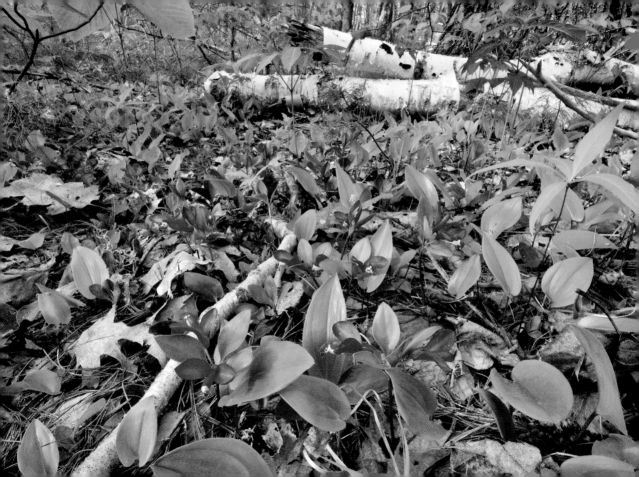

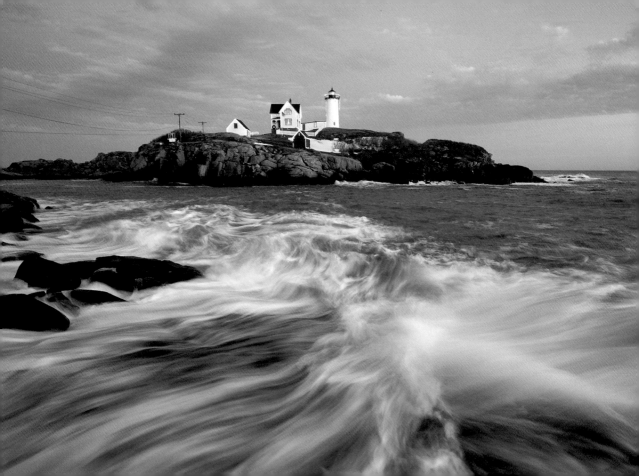

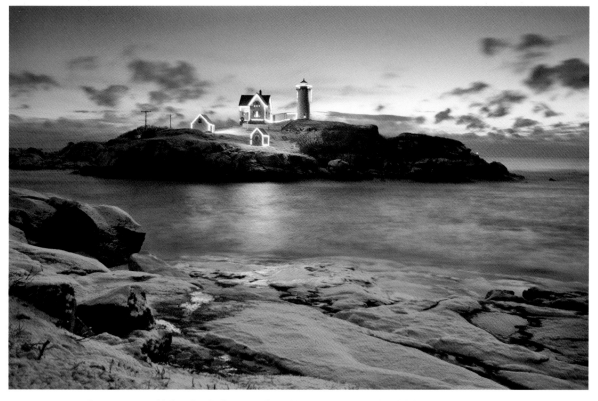

opposite and above *The 1879 Cape Neddick Light, also known as the Nubble Light, is decorated with lights each December and also for a Christmas in July celebration*

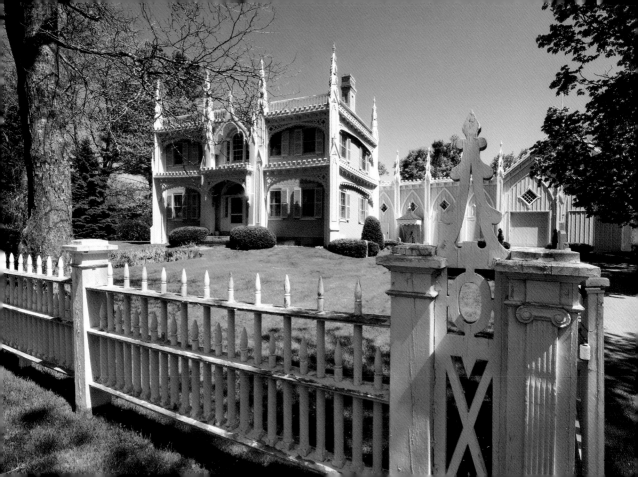

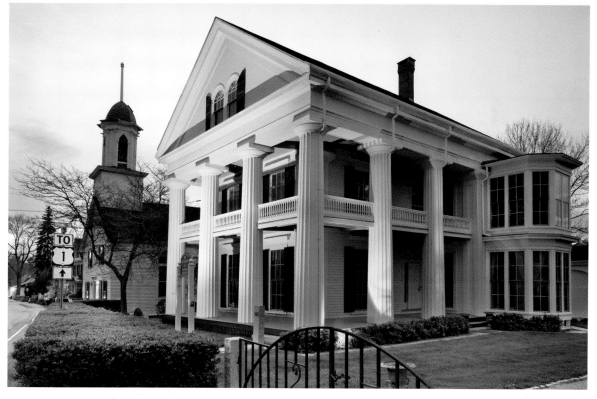

opposite *The Wedding Cake House in Kennebunk, perhaps the most photographed house in Maine*
above *The historic Nott House in Kennebunkport, an 1853 Greek revival house*

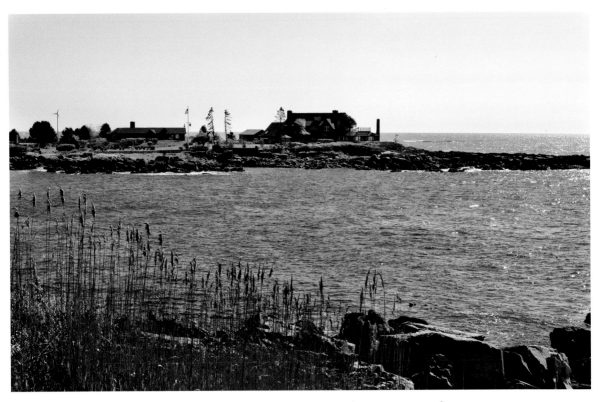

above *This Walker's Point estate in Kennebunkport is the summer home of President George H. W. Bush*

opposite *Kennebunkport beach and St. Ann's Episcopal Church from a bench along Ocean Avenue*

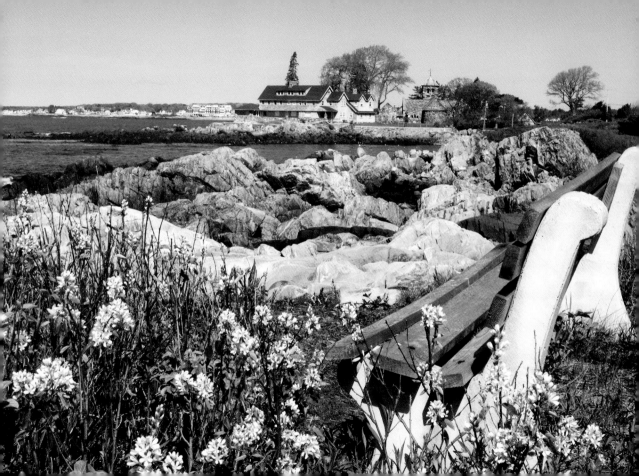

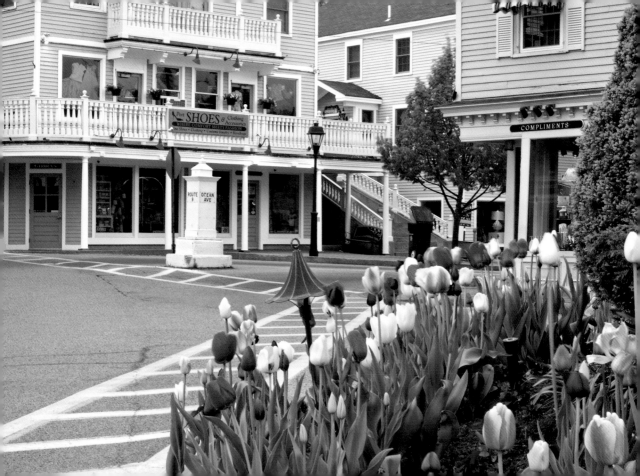

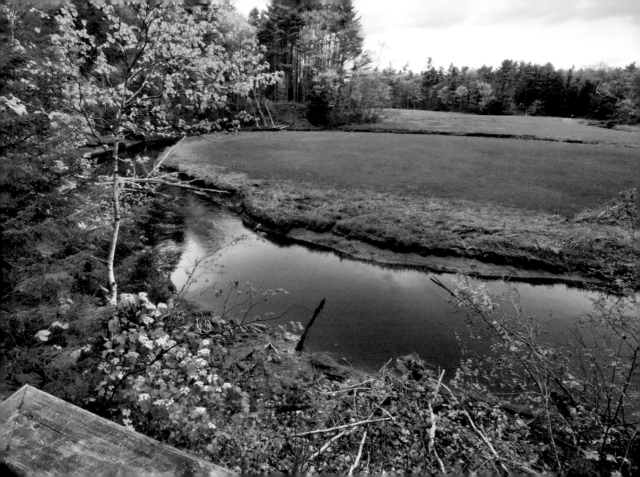

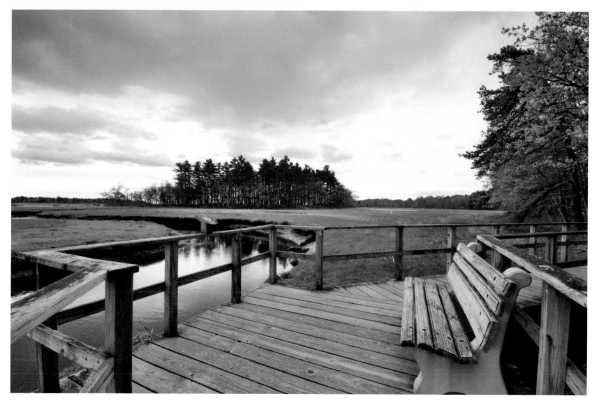

above and opposite *Along the nature trail in the Rachel Carson National Wildlife Refuge south of Kennebunkport. At left, shadbush blooms along the edge of the salt marsh. Above, a view from one of several observation decks.*

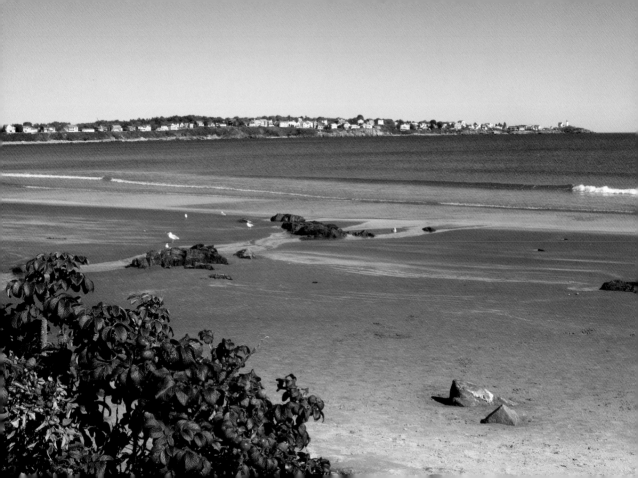

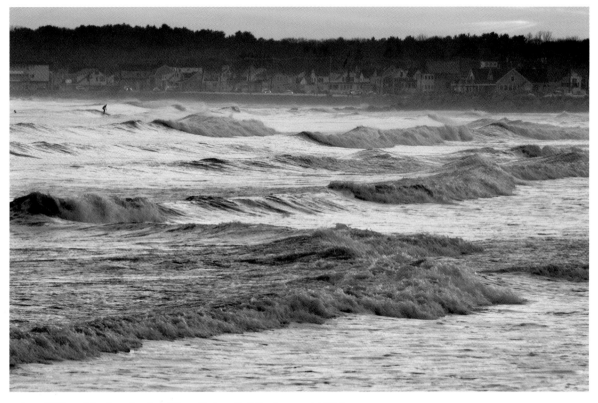

opposite *Wild rose hips along the edge of the walk above York Beach on a quiet fall day*

above *Surfers enjoy the storm waves on a January evening at York Beach*

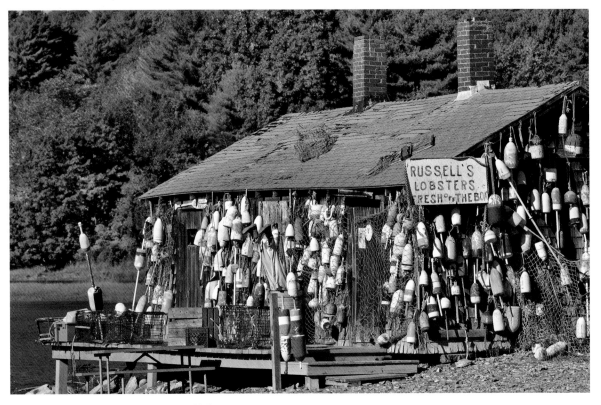

above *A lobster shack along the Cape Neddick River*

opposite *The Wood Island Lighthouse at the mouth of the Saco River, authorized by President Thomas Jefferson and built in 1808*

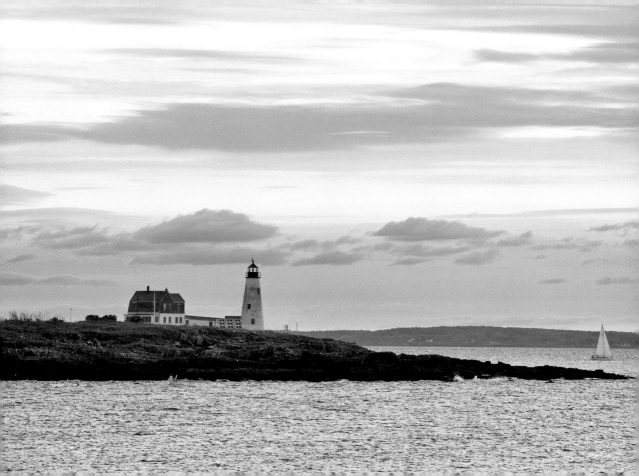

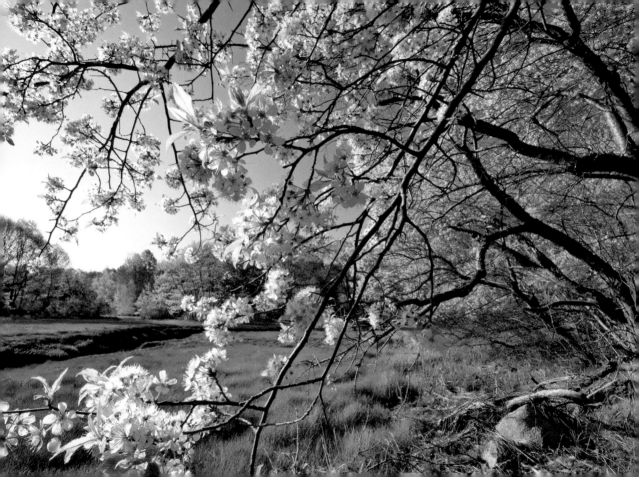

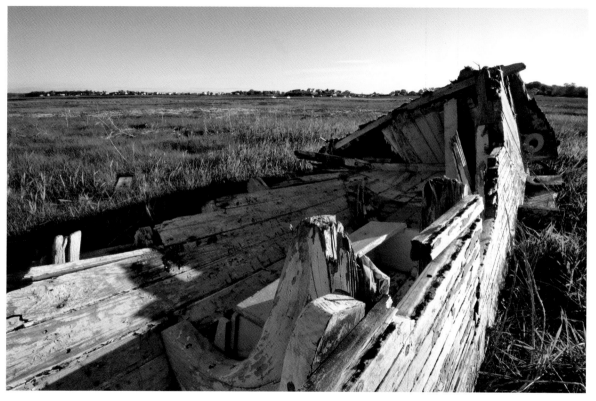

opposite *Wild cherry blossoms along Tyler Brook at the edge of the Rachel Carson National Wildlife Refuge north of Cape Porpoise*

above *A storm-ravaged sailboat hull along the road to Biddeford Pool*

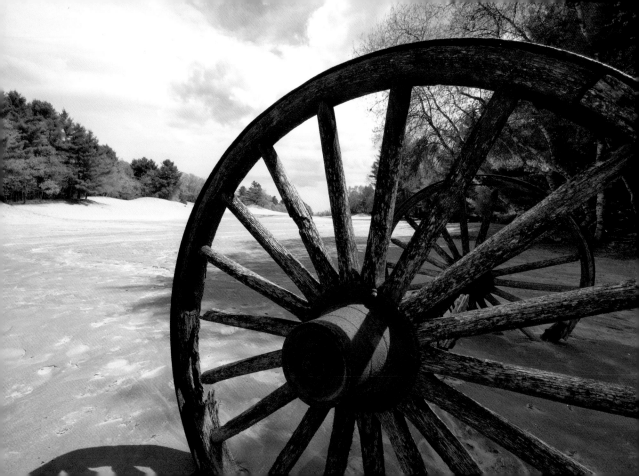

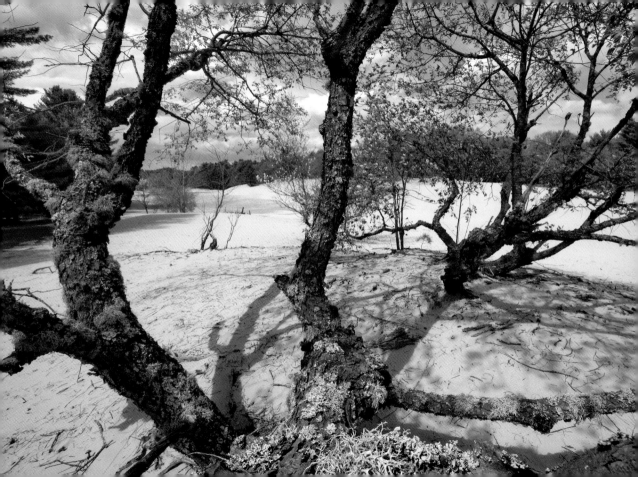

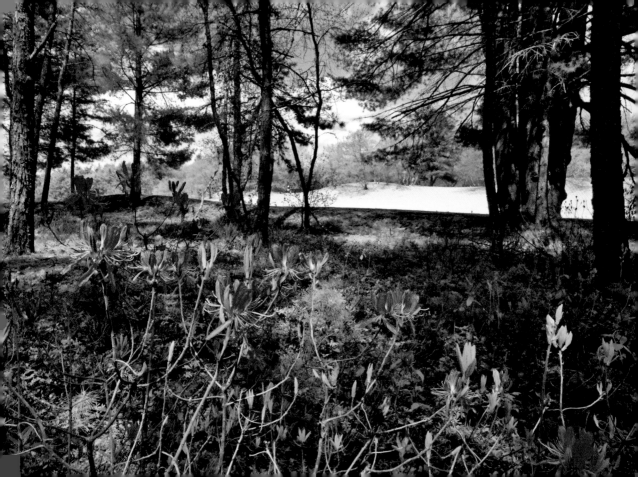

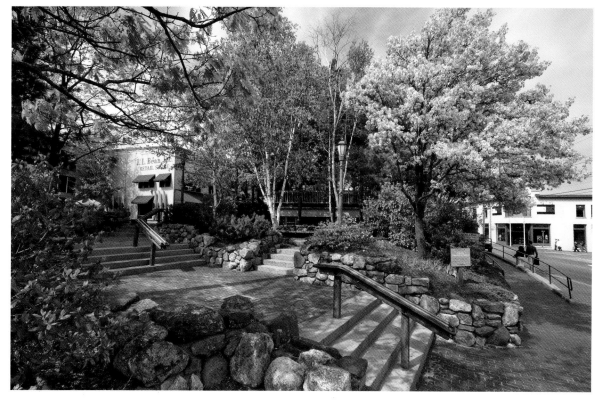

previous page, left *Old wagon wheels at the edge of the Desert of Maine* previous page, right *Blowing glacial silt covers the base of trees near the center of the 40-acre desert* opposite *Wild azaleas bloom in spring at the edge of the woods along the Desert of Maine* above *A small park in full bloom near the L.L. Bean store in downtown Freeport*

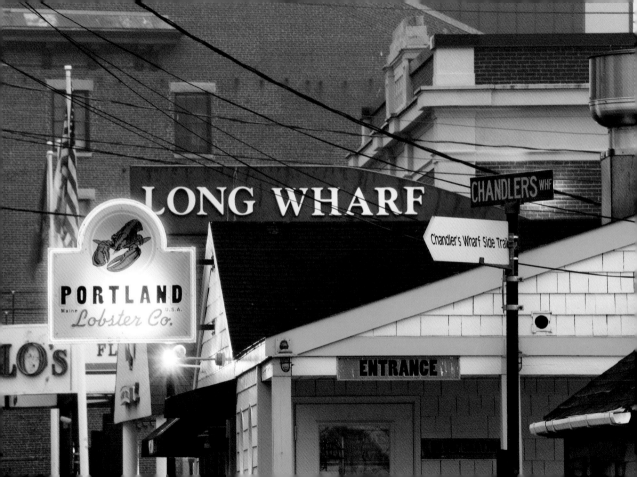

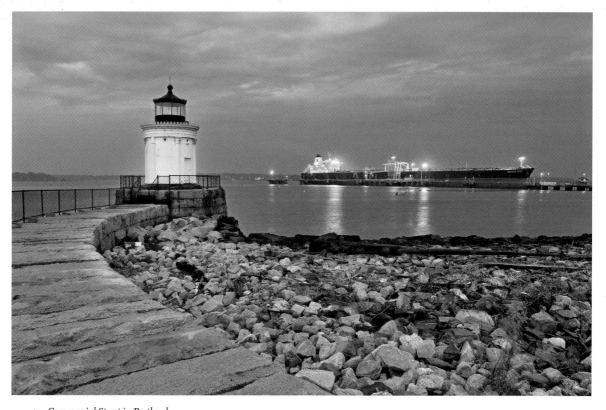

opposite *Commercial Street in Portland*

above *The 1875 cast iron Portland Breakwater Light (also known as the "Bug Light") at the head of Portland Harbor, with a tanker docked in South Portland*

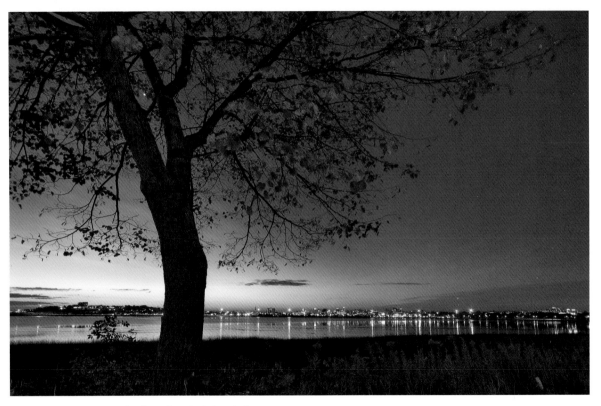

above *Sunrise over Portland, seen from Back Cove Park*

opposite *The Portland skyline at dusk from South Portland—Franklin Towers and the Cathedral of the Immaculate Conception (1869) are on the horizon, while the CAT ferry is docked along the shore*

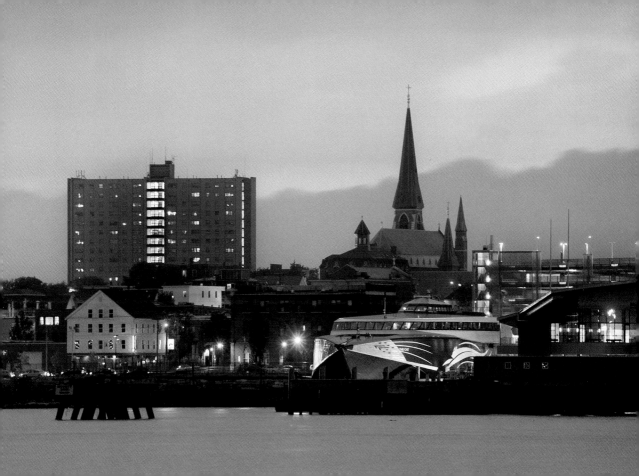

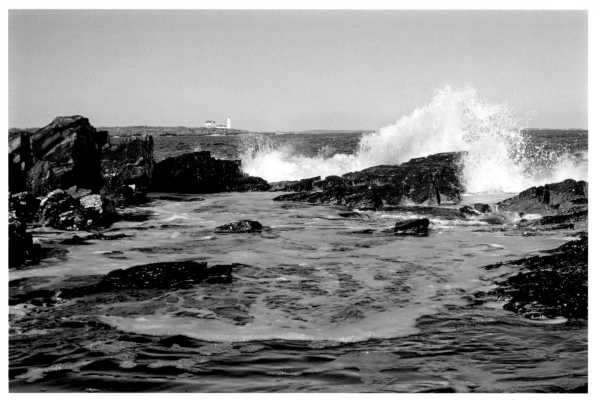

above *Waves crash on the rocky point at Biddeford Pool against a backdrop of the Wood Island Lighthouse*

opposite *A directive from George Washington in 1787 initiated construction of the Portland Head Light on Cape Elizabeth*

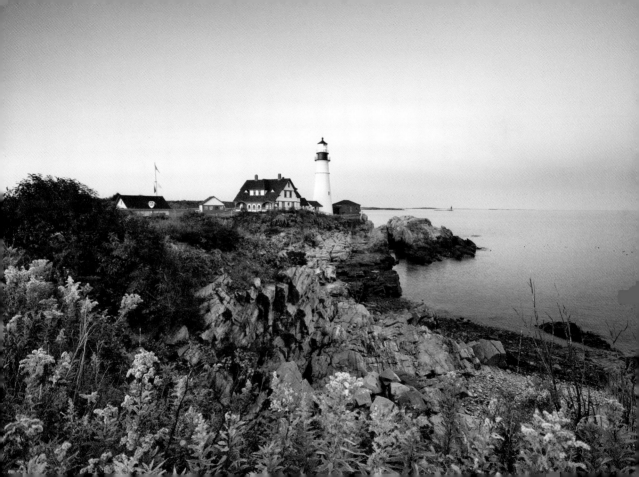

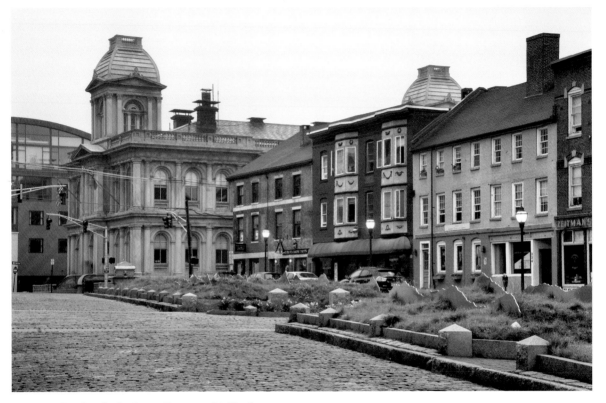

above *Fore Street by the Custom House, completed in 1872*

opposite *Lobster boats, traps, and gear line Widgery Wharf in the Old Port section of Portland*

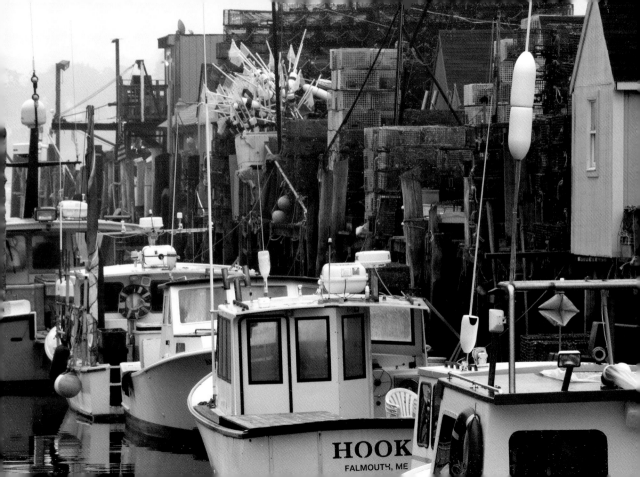

HOOK

FALMOUTH, ME

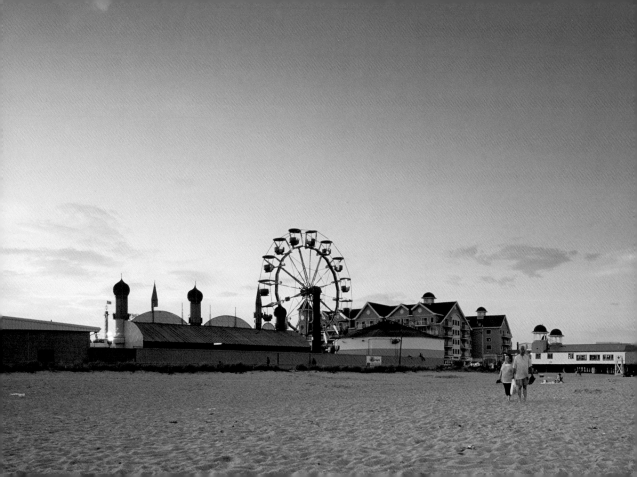

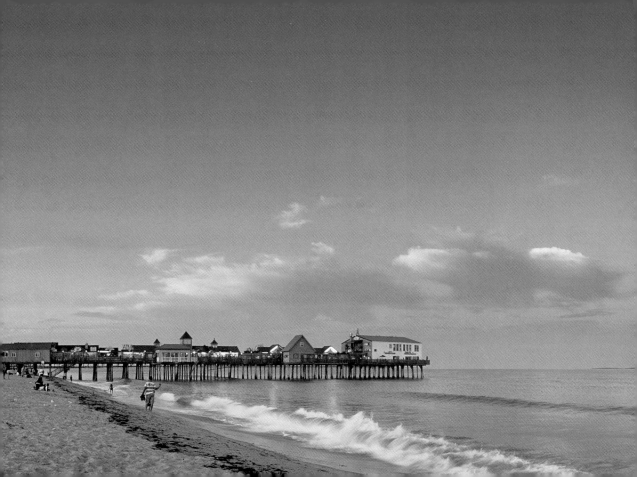

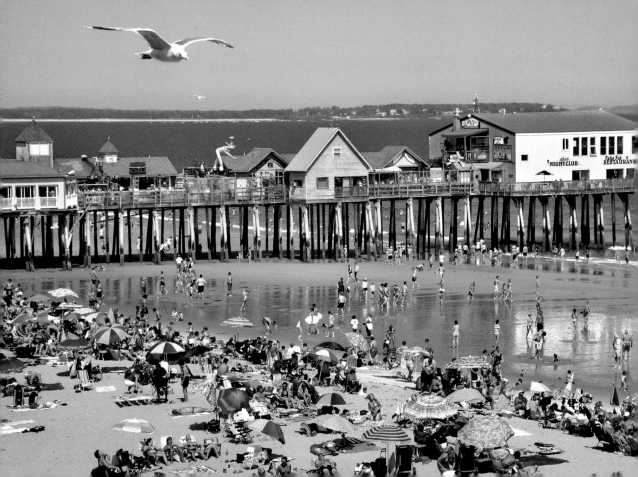

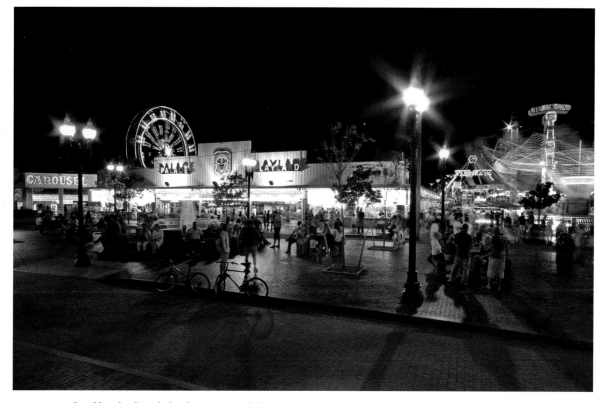

previous page *The Old Orchard Beach shoreline is quiet at dusk*
opposite *A hot summer day by The Pier at Old Orchard Beach*
above *The beach crowd moves to the Palace Playland after the sun goes down*

above *The blockhouse at the Fort McClary State Historic Site in Kittery dates back to 1844 and was recently renovated*

opposite *The Whaleback Light on an island in the Piscataqua River is visible on the horizon in the view from the Fort Foster shoreline on Gerrish Island beyond Kittery Point*

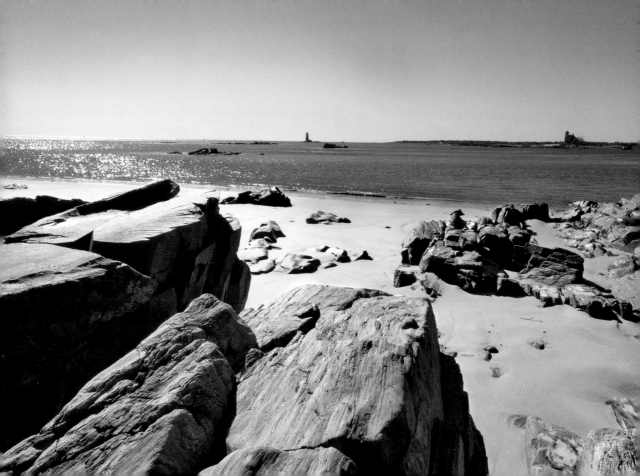

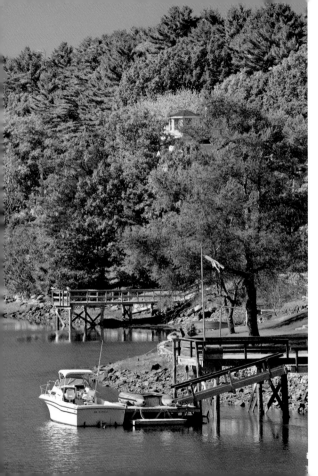

left **Along the shore between Gerrish Island and Kittery Point**
opposite **A pair of mallards and reflections in the Josias River in Ogunquit**

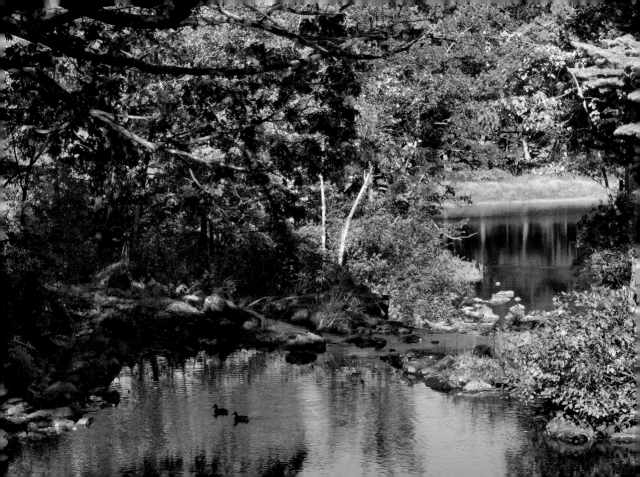

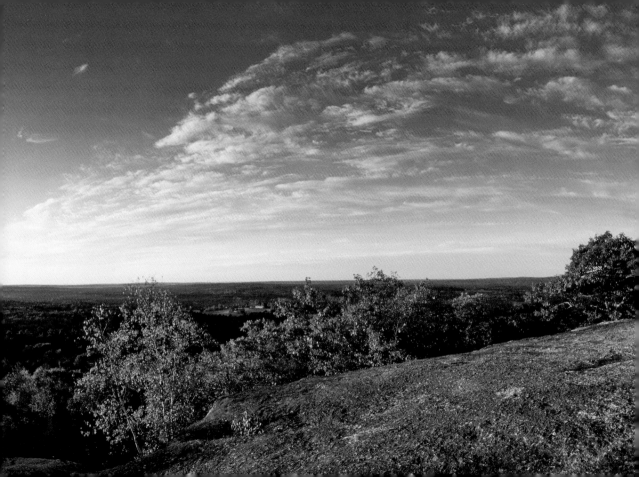

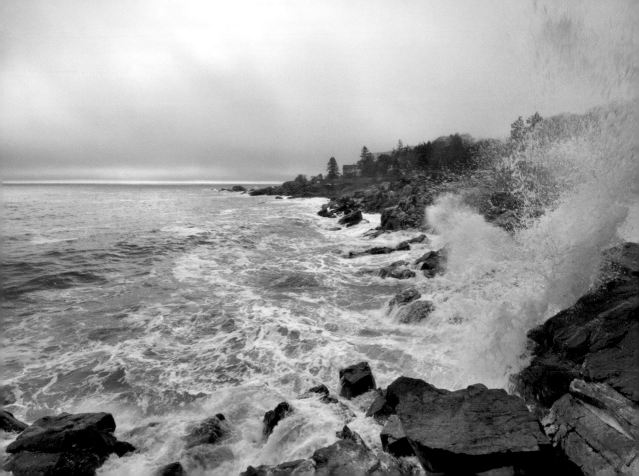

previous page *Sunrise light, fall colors, and the expansive view
on the mountain summit in Bradbury Mountain State Park*
opposite *The stormy winter surf sends a spray many feet in the air
at the Blowing Cave along Ocean Avenue in Kennebunkport*
right *A pair of anchors await the rising tide in the
Kennebunk River*

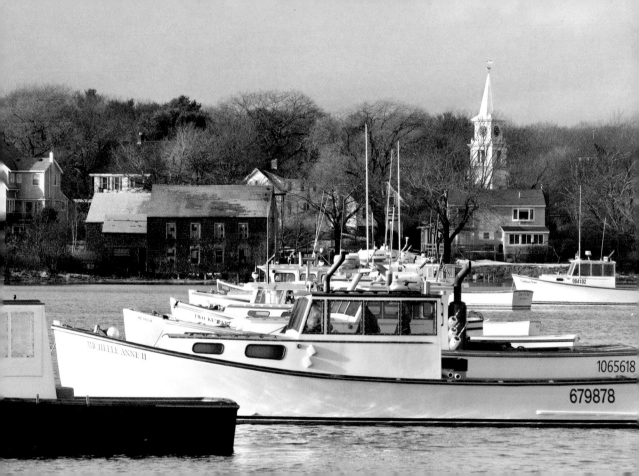

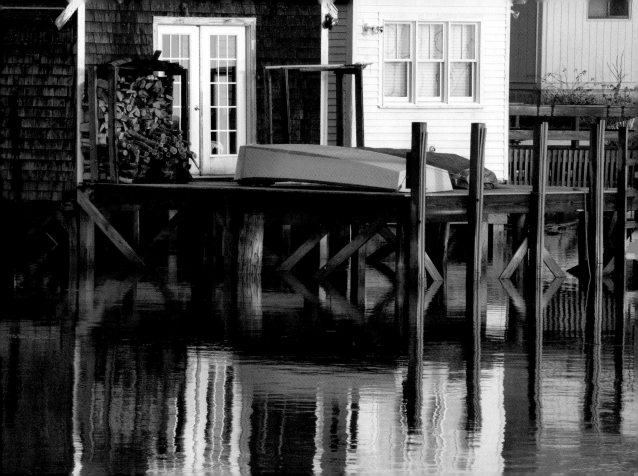

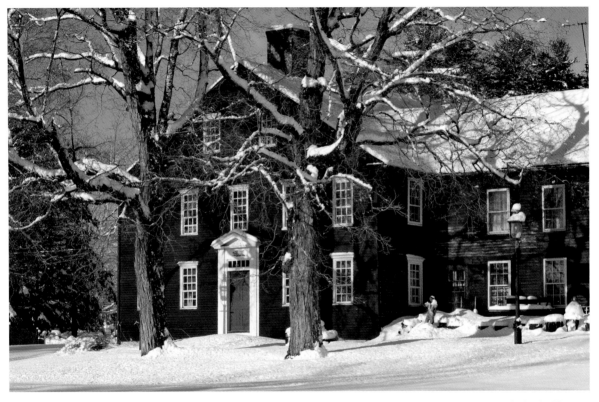

previous page *Cape Porpoise harbor; left, moored lobster boats face the wind and winter sun; right, shoreline reflections of harbor buildings*

above *A colonial style homestead in downtown Kennebunk* opposite *Only the seagulls are out on the wintry morning at Wells Beach*

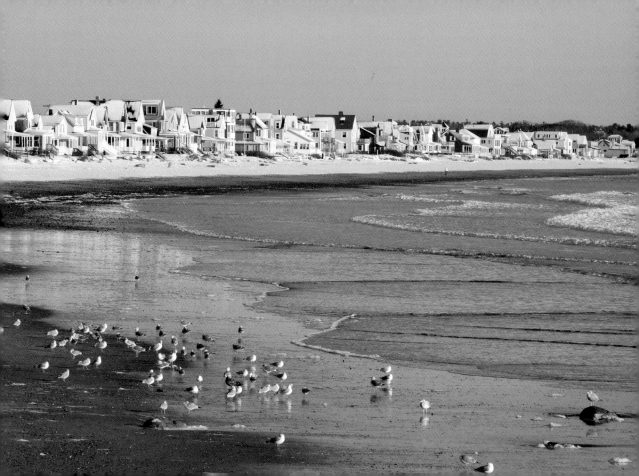

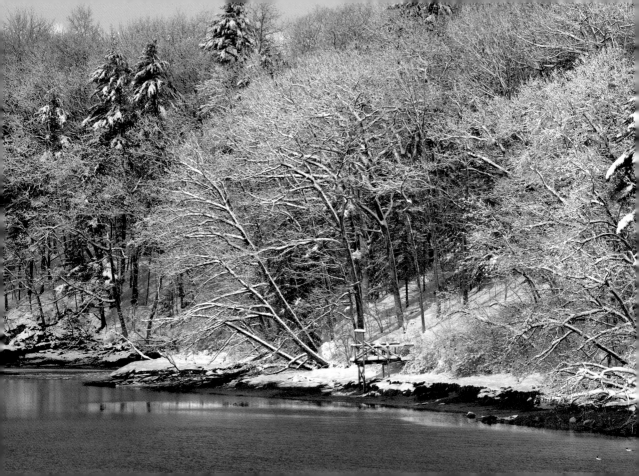

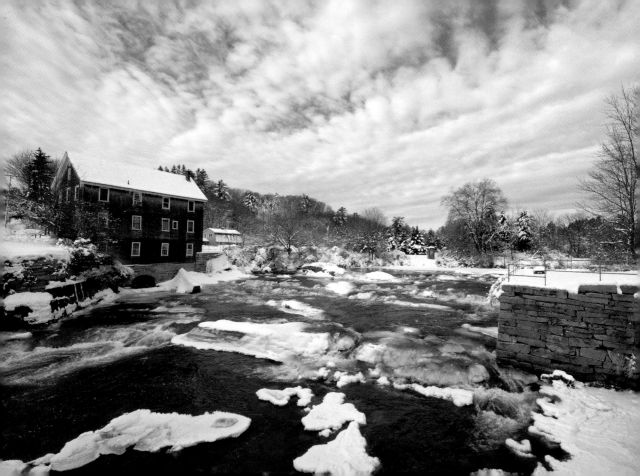

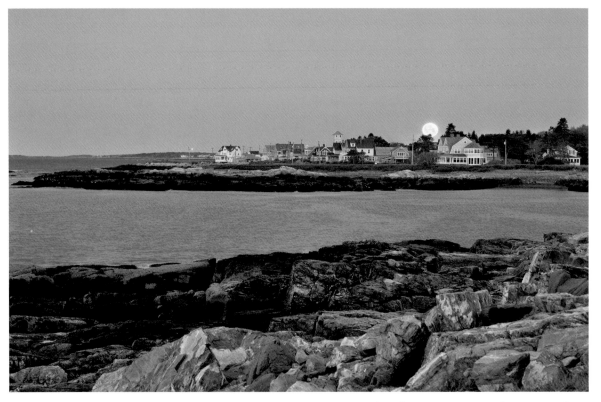

previous page, left *A winter snow covers every branch along the Presumpscot River in Falmouth* previous page, right *A historic grist mill at the lower falls on the Royal River in Yarmouth* above *The full moon at dawn, setting behind the shoreline homes of Biddeford Pool* opposite *Sunrise from the East Sanctuary at Biddeford Pool*

Mid Coast Mountains and Islands

❧❧❧

~ From Brunswick to Bucksport ~

Bath, Popham Beach, Boothbay, Pemaquid Point, Port Clyde,

Owls Head, Monhegan Island, Rockport, Camden,

Belfast, and Penobscot Bay

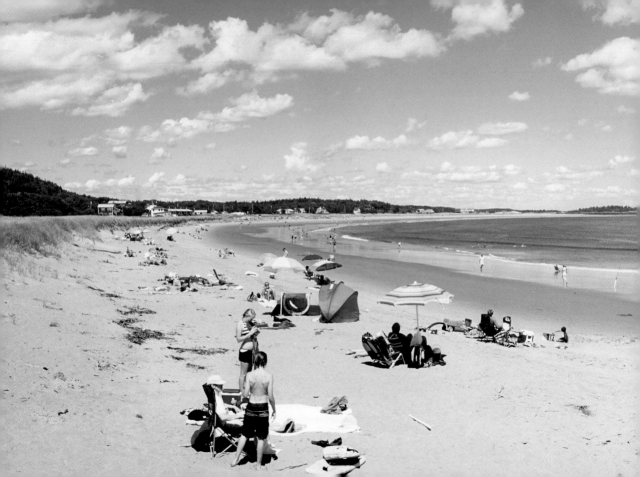

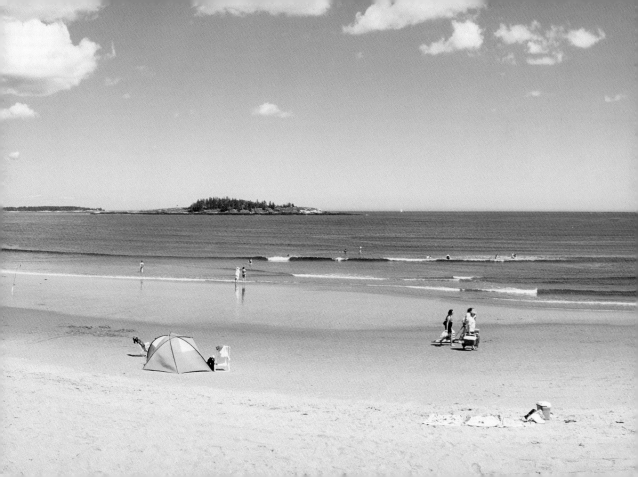

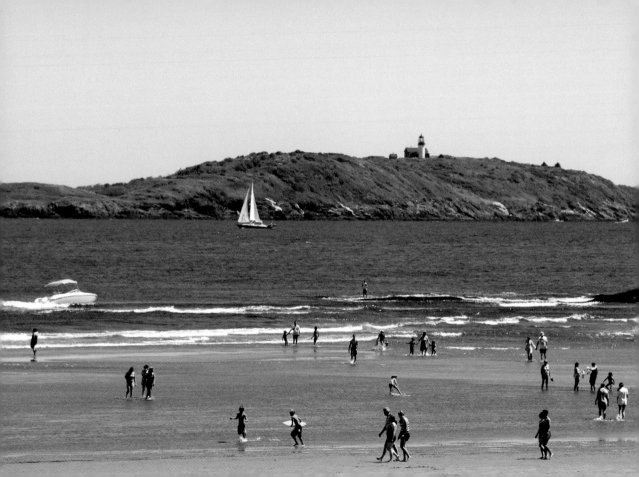

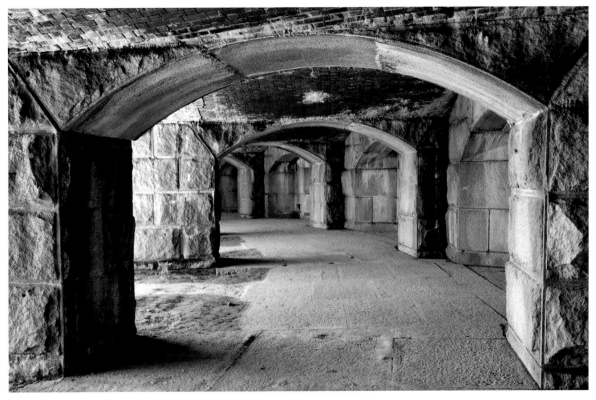

chapter opener *Storm clouds advance across Muscongus Bay above a sailboat* previous page *A beautiful summer day at the popular Popham Beach State Park* opposite *Seguin Island Lighthouse at the mouth of the Kennebec River from Popham Beach* above *The semicircular Fort Popham was built in 1862 for the Civil War*

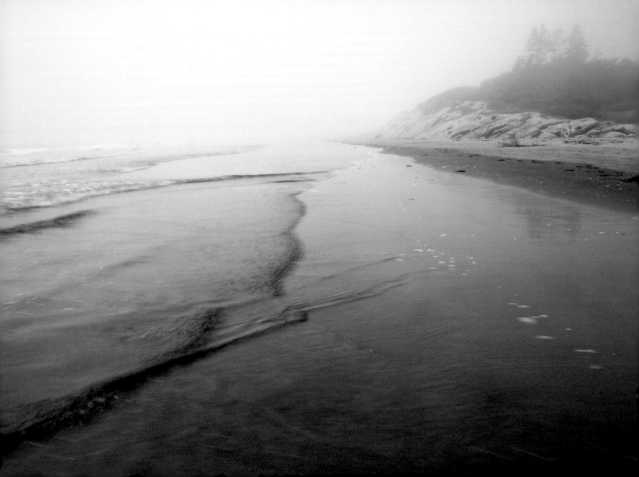

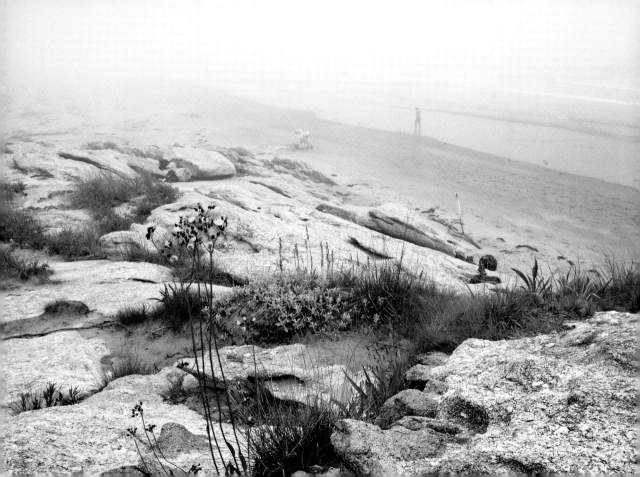

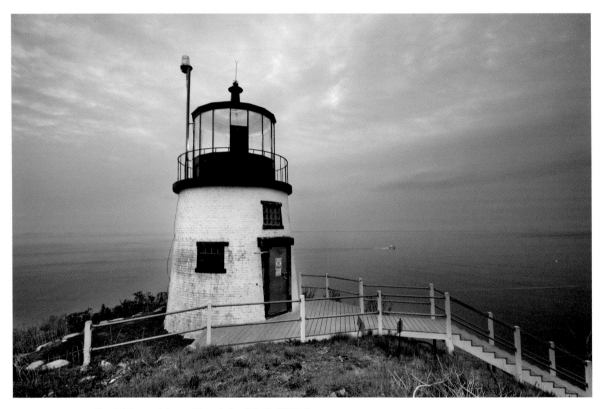

previous pages *Coastal fog envelops a wild sandy beach in the Phippsburg area*

above *Owls Head Lighthouse and lobster boat at dawn*

opposite *Low tide along Penobscot Bay at Owls Head*

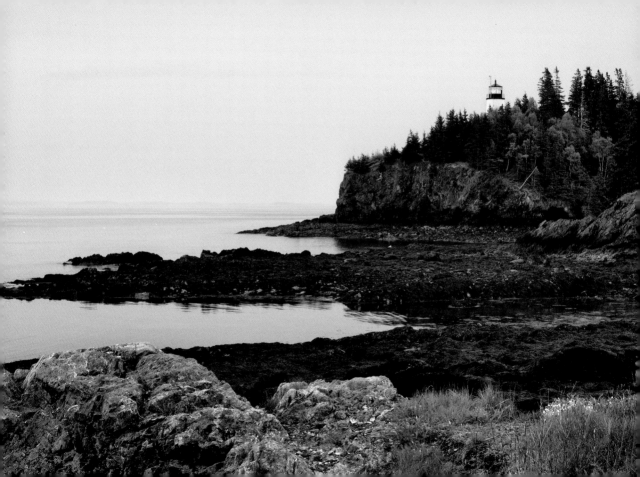

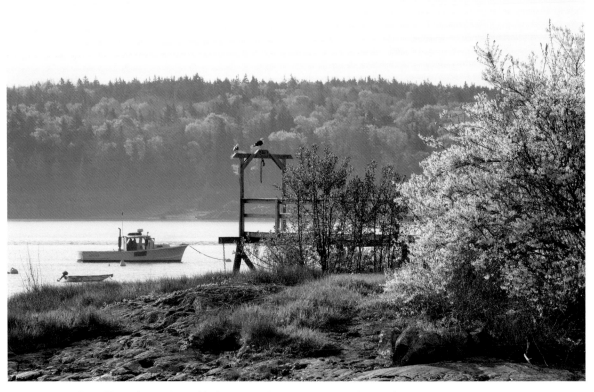

above *Forsythia in bloom along Owls Head harbor*
opposite *An abandoned fisherman's home along the harbor shore*

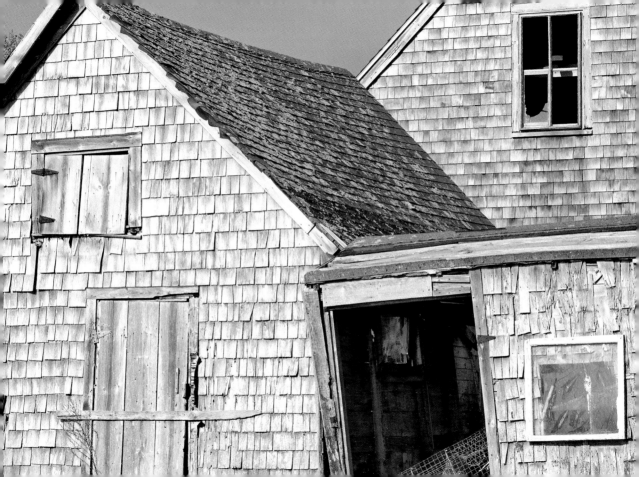

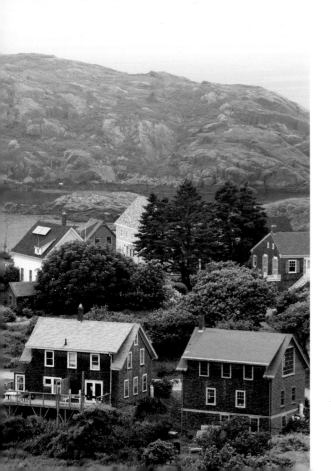

left *Numerous artists have visited Monhegan Island, including Henri Bellows, Rockwell Kent, Ida Proper, and Jamie Wyeth*
opposite *Looking to Manana Island and Monhegan Harbor from the road to the ferry dock*

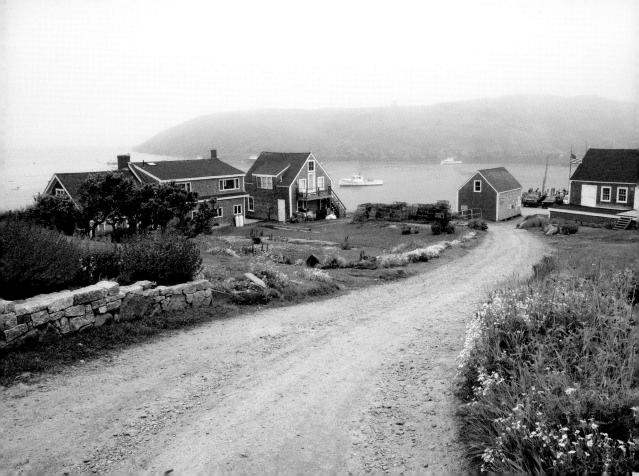

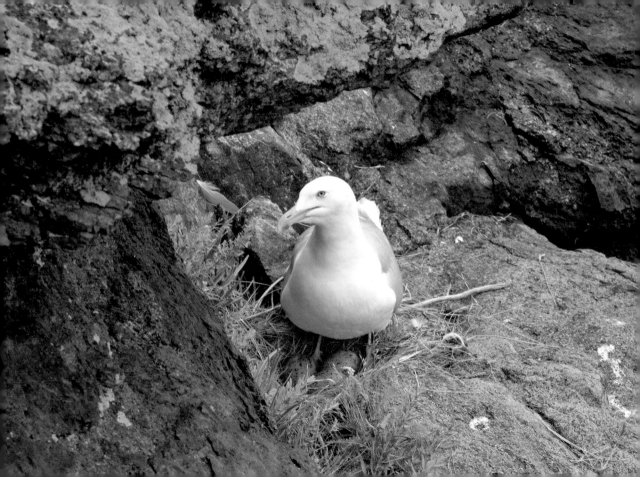

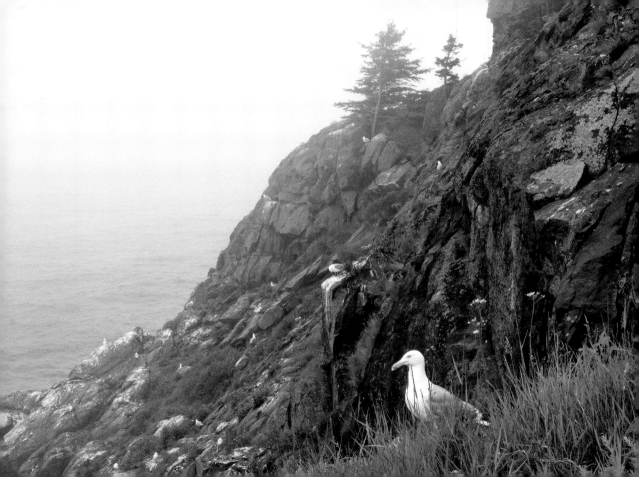

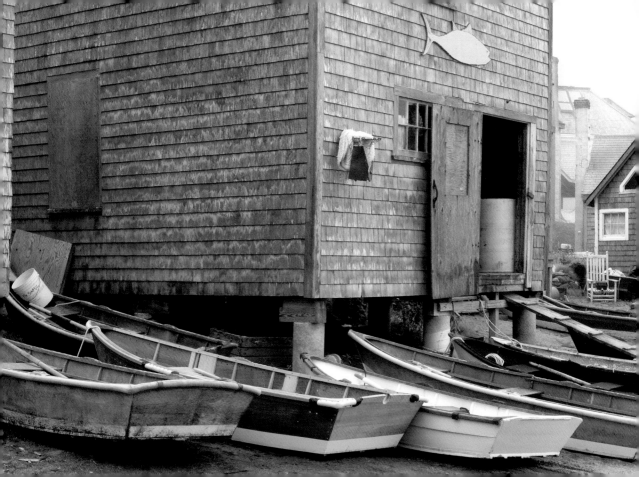

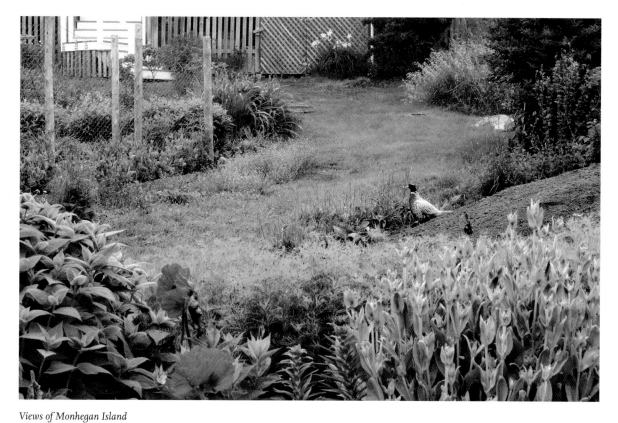

Views of Monhegan Island

Seagulls nest among the rocky heights of White Head on the rugged ocean side

Fishing dinghies line the shore in the village *A ring-necked pheasant wanders among the backyards and gardens*

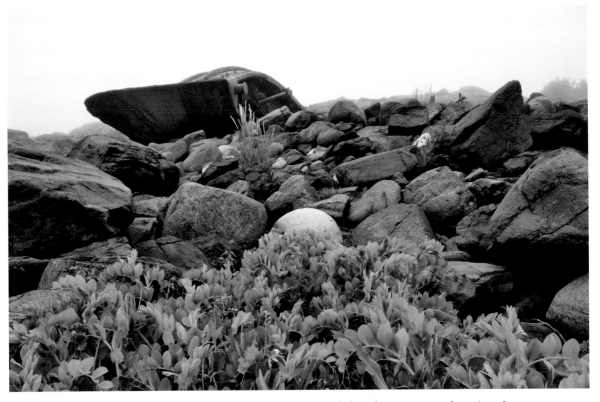

above and opposite *The D.T. Sheridan, a 110-foot long tugboat, was shipwrecked at Lobster Cove on Monhegan in 1948*

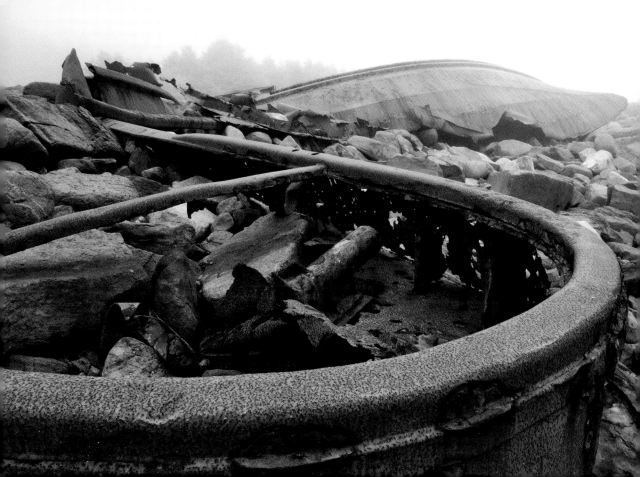

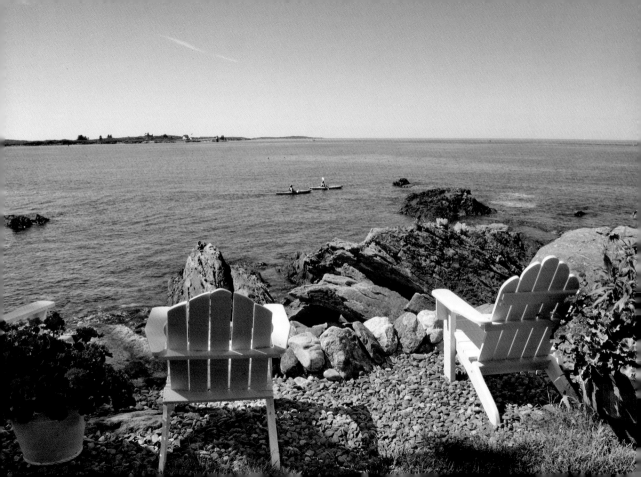

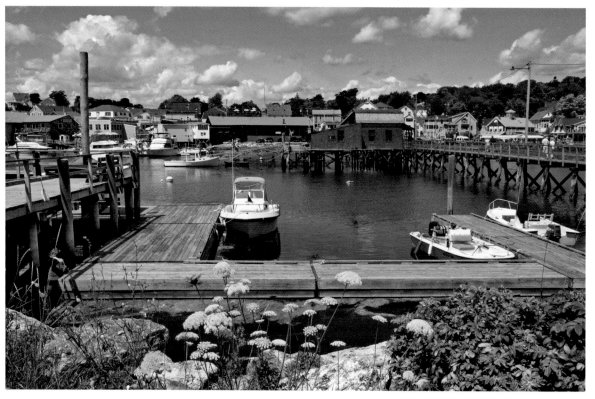

previous page, left *Buttercups line the edge of the Cliff trail on the east side of Monhegan*

previous page, right *The view from Ocean Point looks across to the Ram Island Light*

above and opposite *Boothbay Harbor is a popular summer destination*

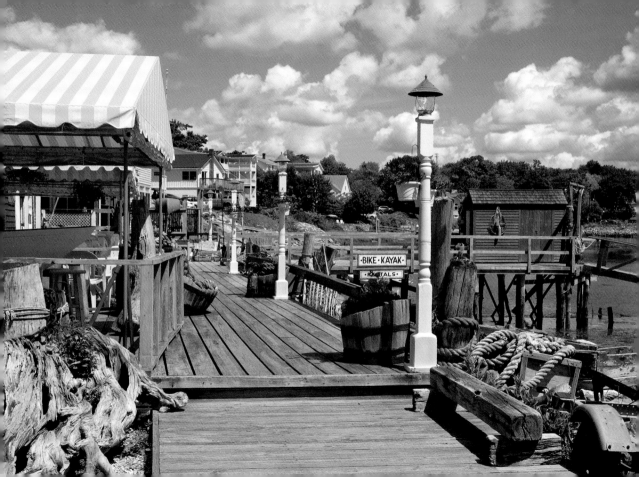

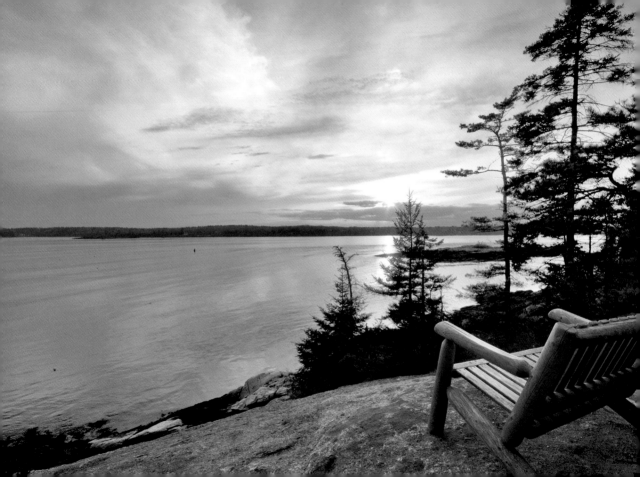

View of the Sheepscot River at sunset from the Boothbay Region Land Trust's Porter Preserve
More than two miles of nature trails wind among the plantings of the Coastal Maine Botanical Gardens in Boothbay

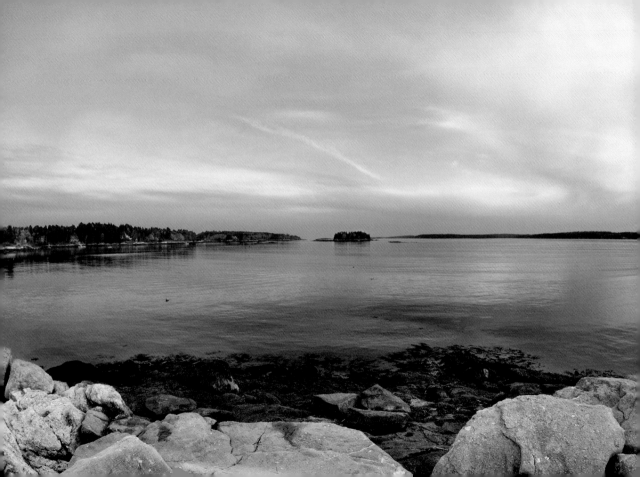

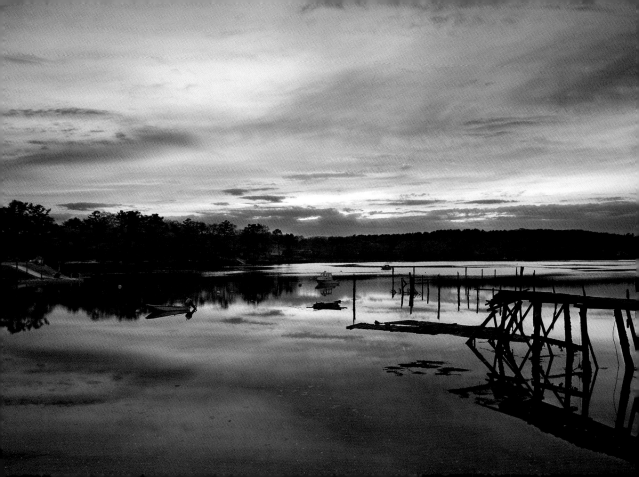

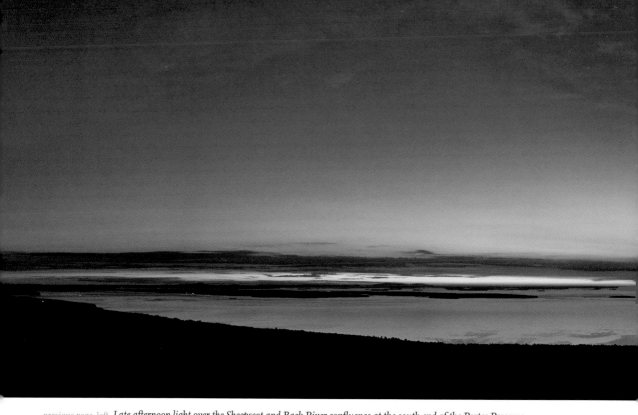

previous page, left *Late afternoon light over the Sheepscot and Back River confluence at the south end of the Porter Preserve*

previous page, right *Sunset over the Back River from the Barters Island bridge in Boothbay*

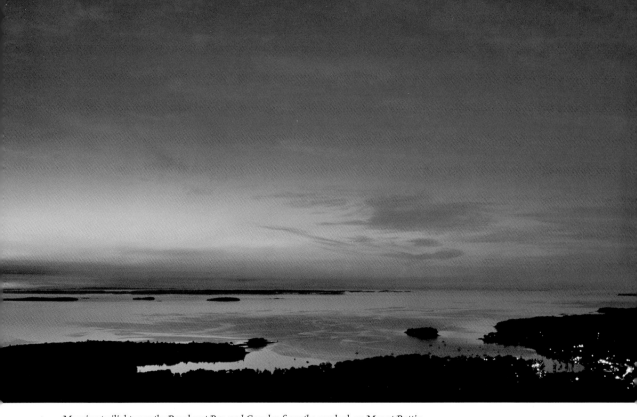

above *Morning twilight over the Penobscot Bay and Camden from the overlook on Mount Battie*

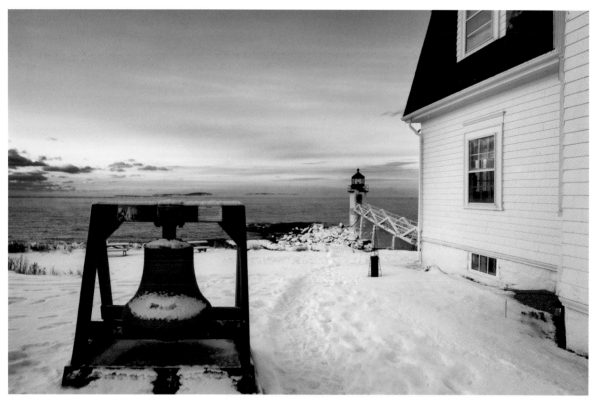

above and opposite *The present Marshall Point Lighthouse has helped protect boaters entering Port Clyde Harbor since 1858*

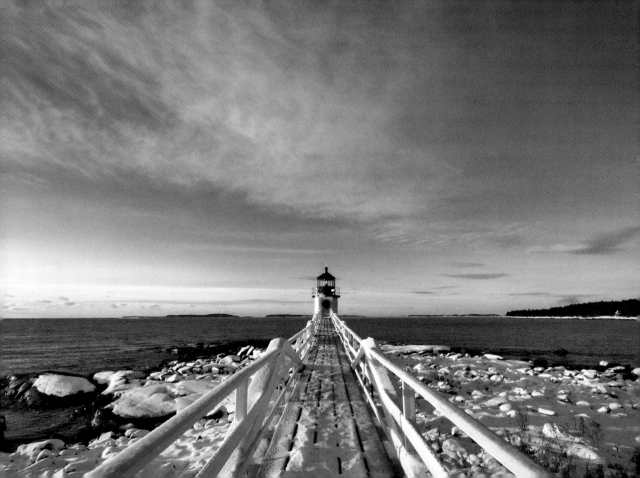

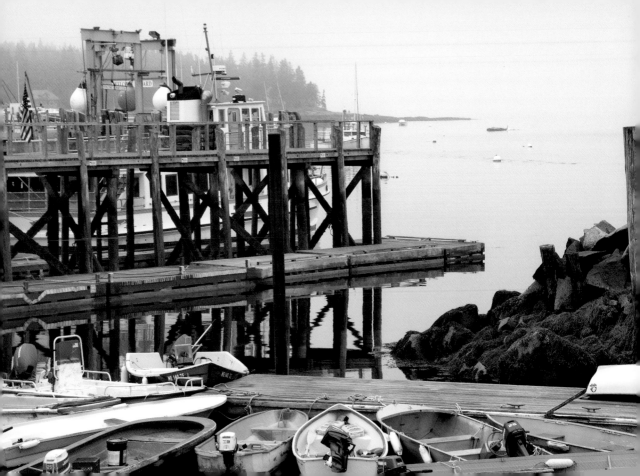

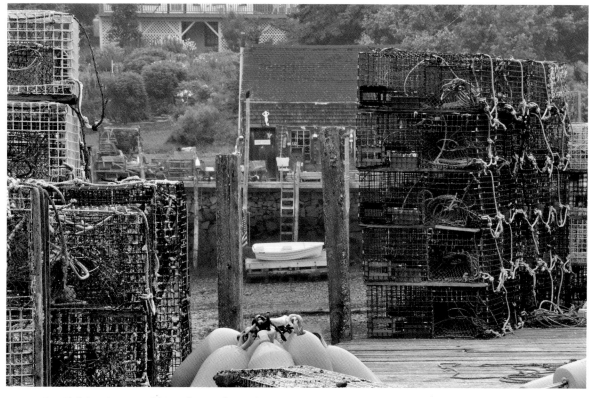

opposite *Port Clyde is a picturesque fishing village on the tip of St. George Peninsula*

above *Lobster traps fill the commercial docks*

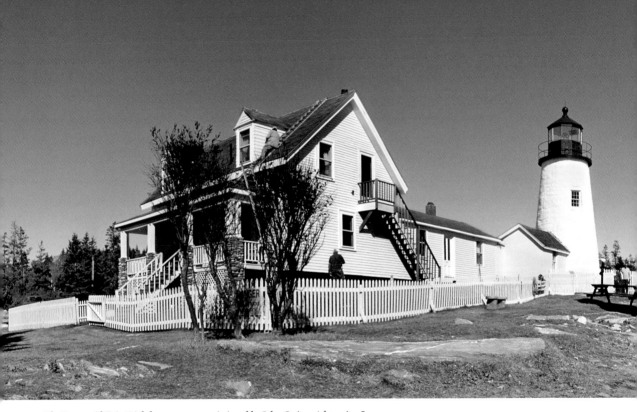

The Pemaquid Point Lighthouse was commissioned by John Quincy Adams in 1827 but was rebuilt in 1835 and again in 1857 on orders from President James Buchanan

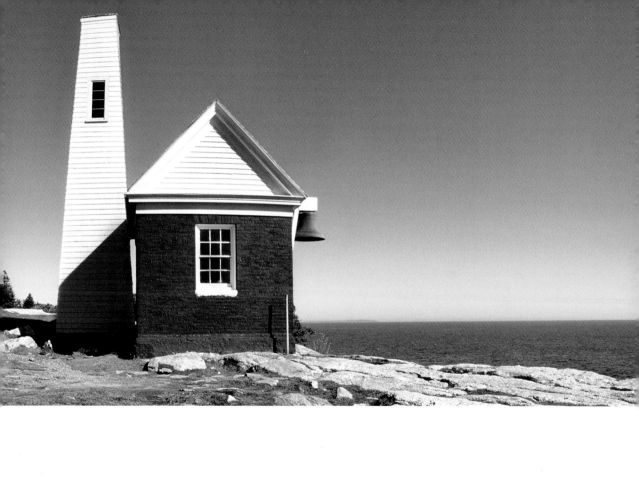

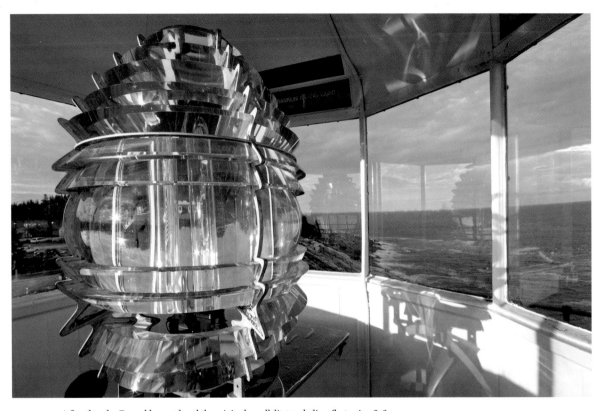

above *A fourth order Fresnel lens replaced the original candlelit parabolic reflector in 1856*

opposite *The Pemaquid Point Light seen from the reflecting pool found along the unique whaleback rock extending south into the ocean and separating Johns Bay from Muscongus Bay*

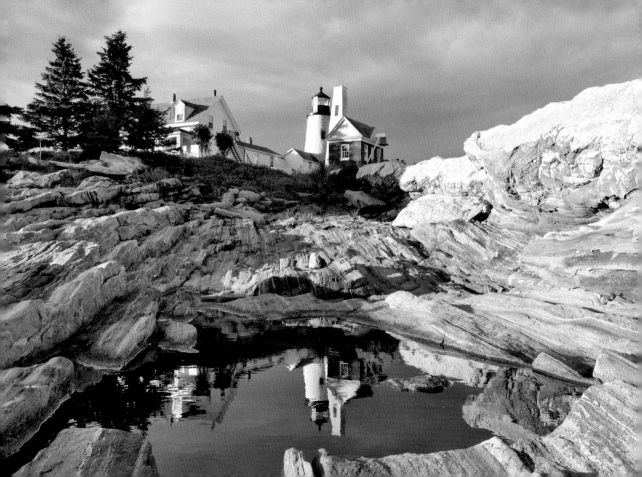

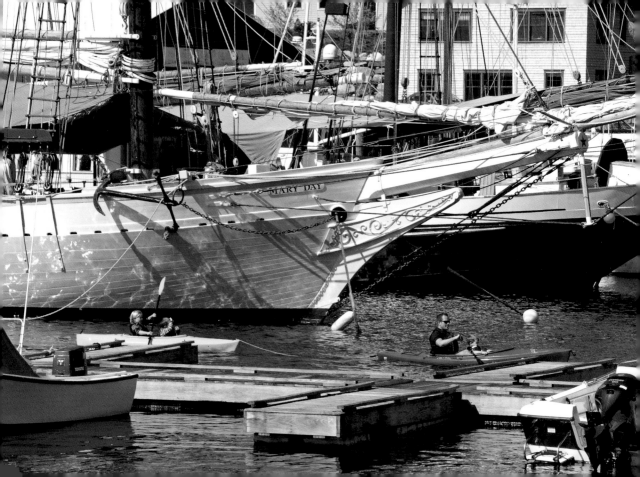

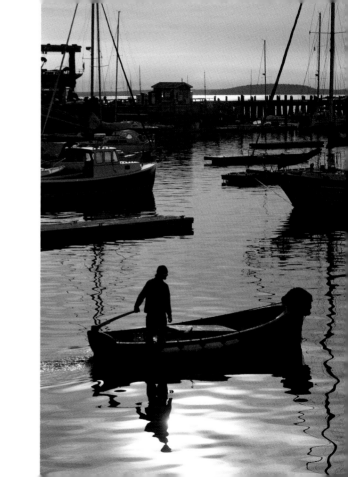

opposite *Camden Harbor, kayaking among the windjammers*
right *A fisherman heads out to his boat in early morning light*

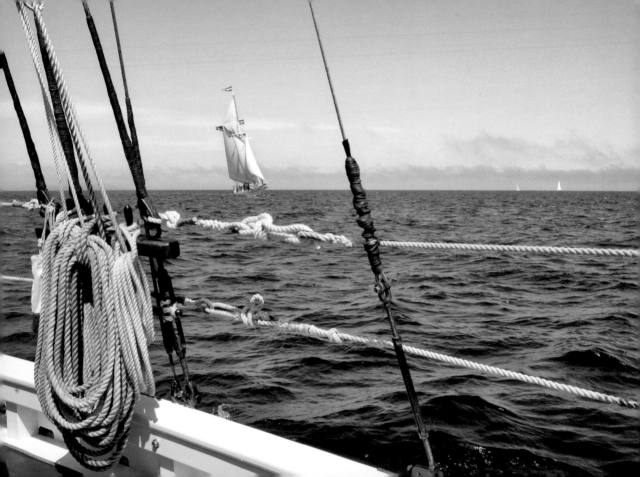

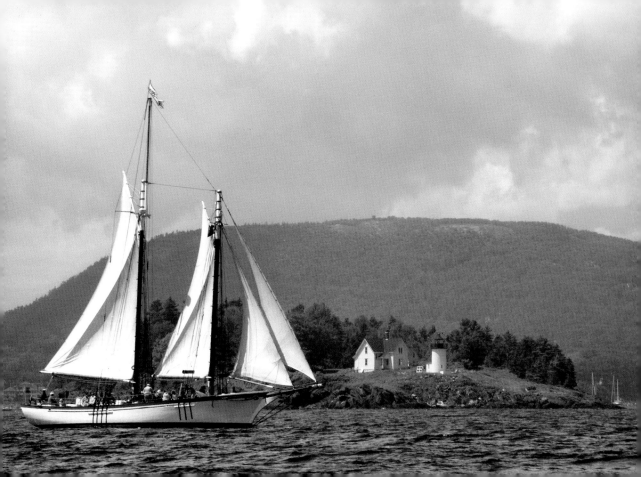

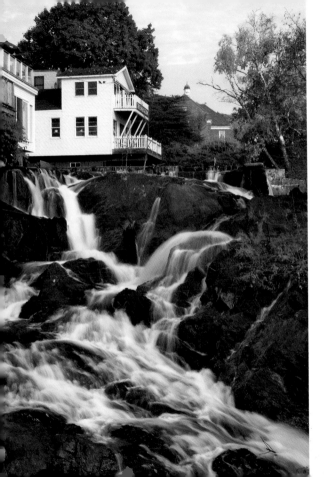

previous page, left *Sailing in Penobscot Bay aboard the historic 1918 schooner the* Surprise

previous page, right *The schooner* Appledore II *sails by the Curtis Island Light against a backdrop of the Camden Hills*

opposite *Norumbega Inn is a historic 1886 castle overlooking Camden Harbor and the Penobscot Bay*

left *The stream that ends as a waterfall above Camden Harbor once powered numerous mills in the area*

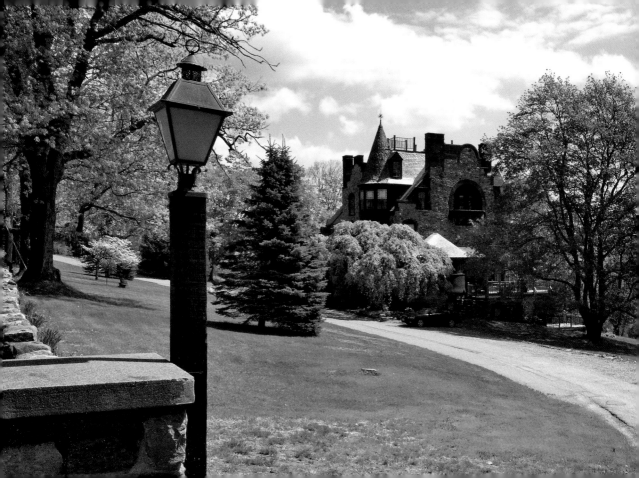

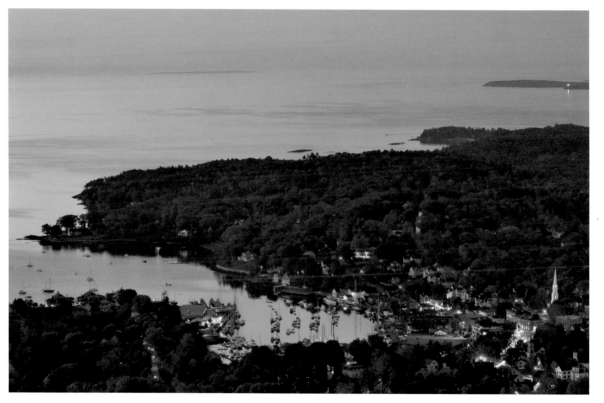

Sunrise views from Mount Battie
above *Camden Harbor* opposite *Overlooking Penobscot Bay and the Down East coastline*

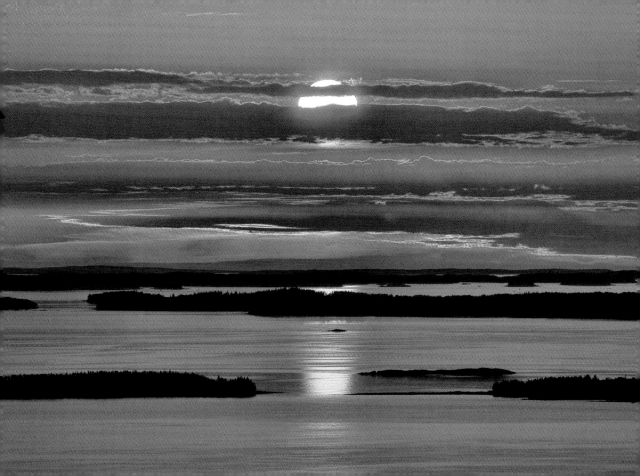

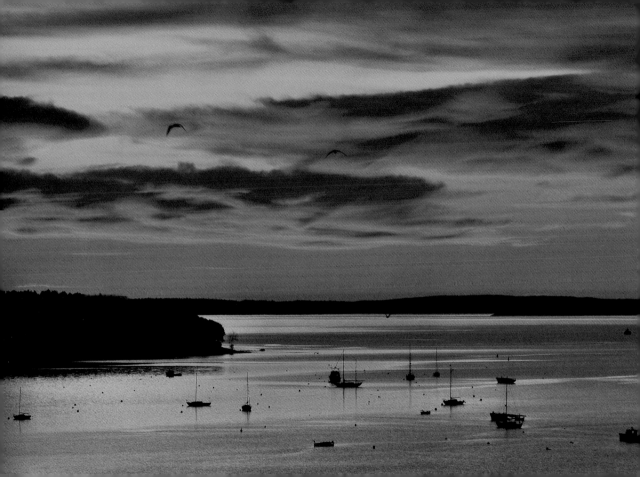

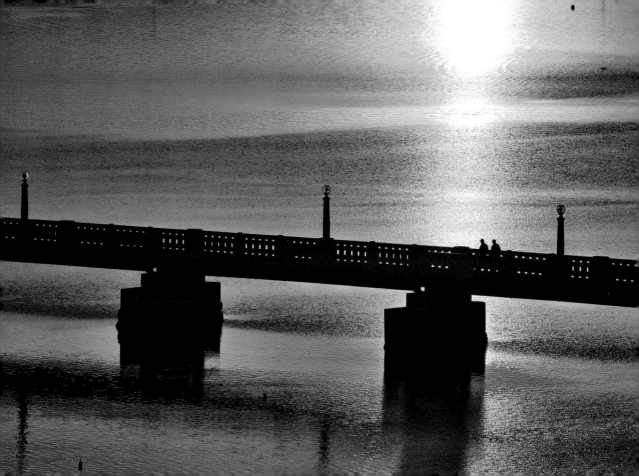

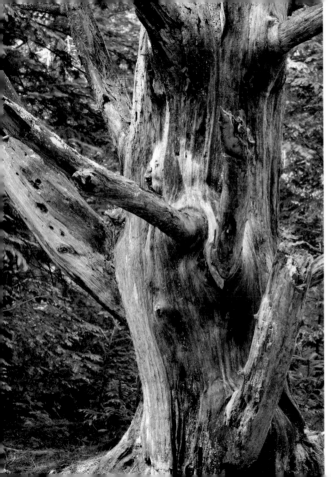

previous page, left *Morning clouds and seagulls over Belfast Harbor*
previous page, right *Taking a morning walk across the old Belfast Harbor bridge*
left *The Nature Conservancy's Fernalds Neck Preserve— an old pine along the trail has a rather unique character*
opposite *View across Megunticook Lake*
following pages *Sunset light on a beautiful fall day along the shoreline of Damariscotta Lake State Park*

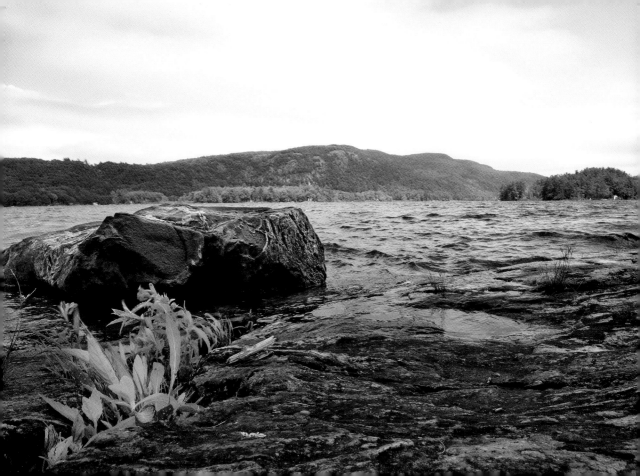

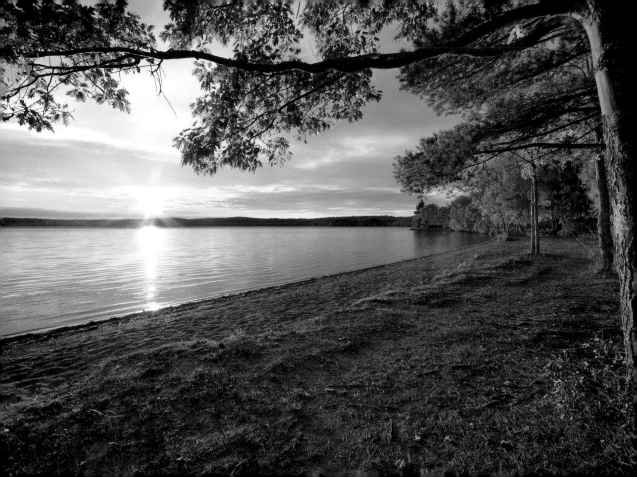

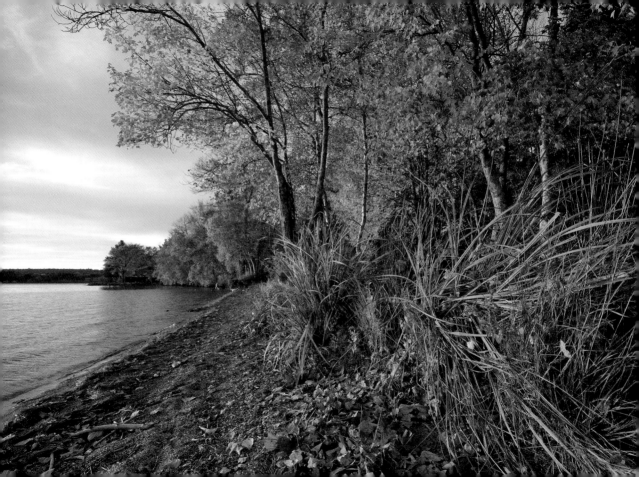

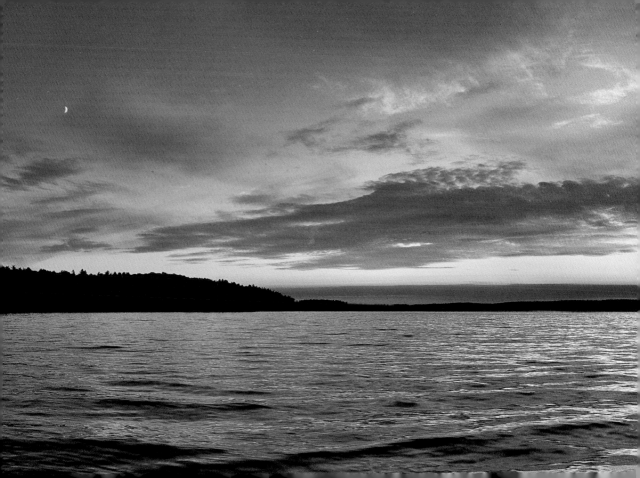

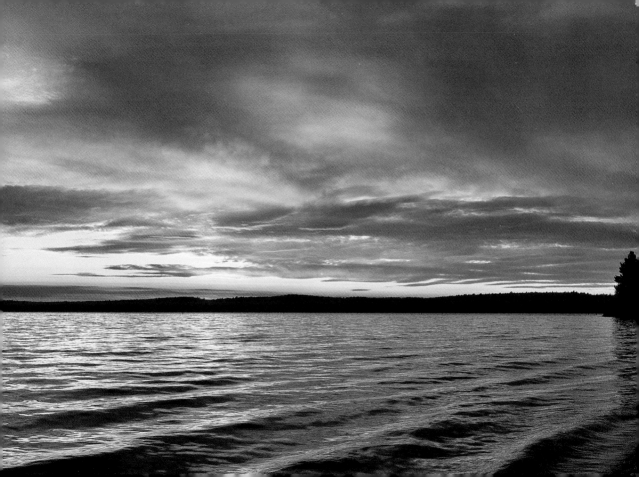

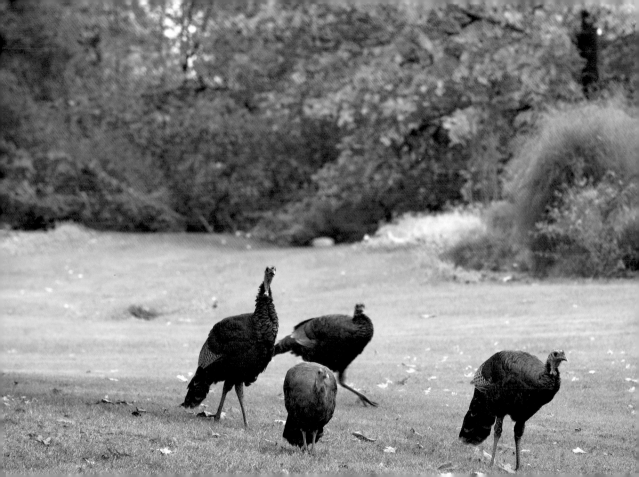

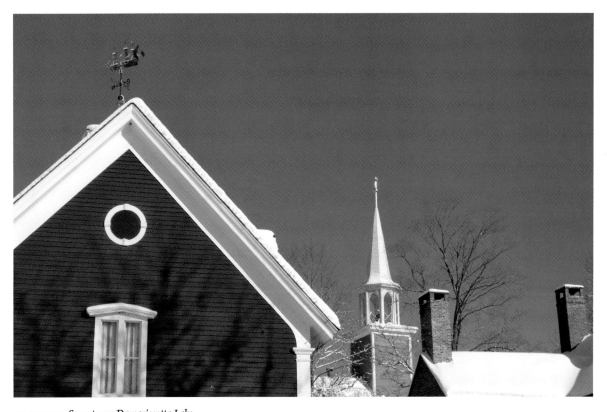

previous page *Sunset over Damariscotta Lake*
opposite *Wild turkeys feeding on a lawn just outside Belfast*
above *Snow covers the rooflines of Wiscasset buildings and the steeple of St. Philip's Episcopal Church*

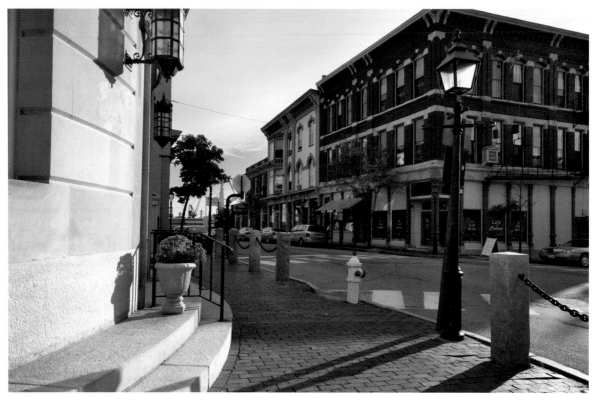

above *Front Street in historic downtown Bath by the entrance to City Hall*
opposite *The Bath Iron Works has been building ships along the Kennebec River since 1884*

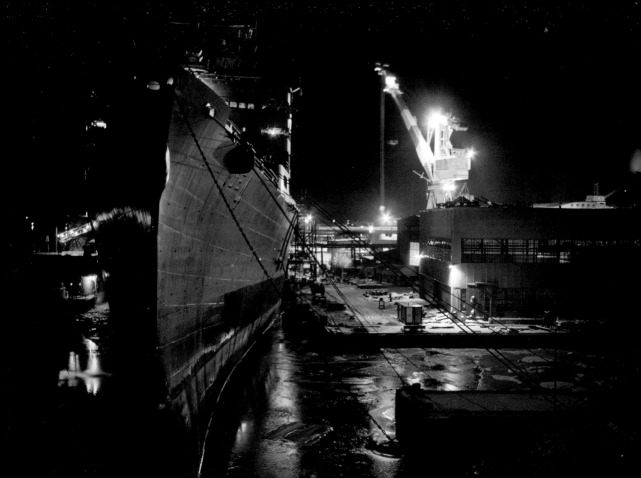

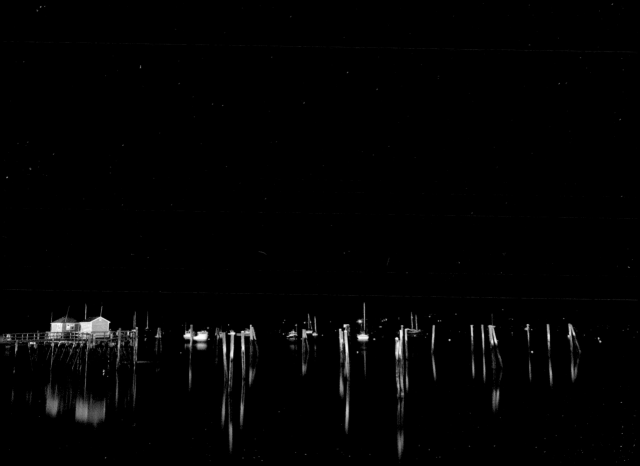

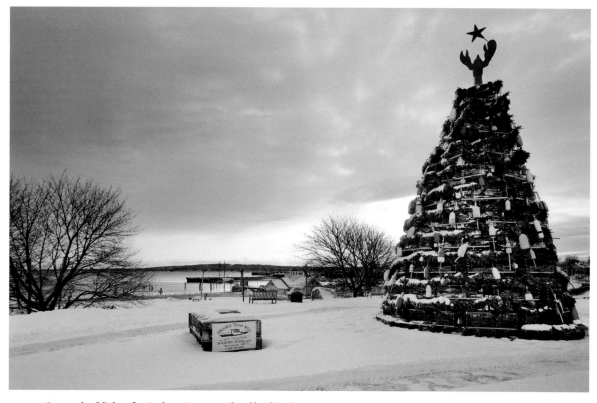

opposite *Stars and soft light reflect in the quiet waters of Rockland Harbor*
above *Rockland decorates for Christmas with a lobster trap tree*
following page *A snow-covered wetland along the Back River Creek along Route 1 near Woolwich*

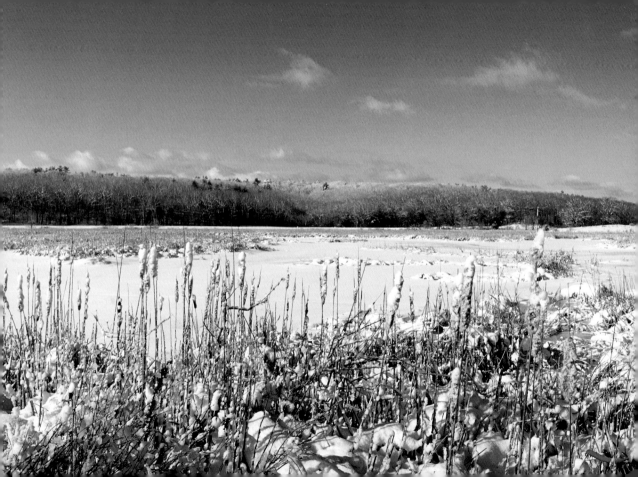

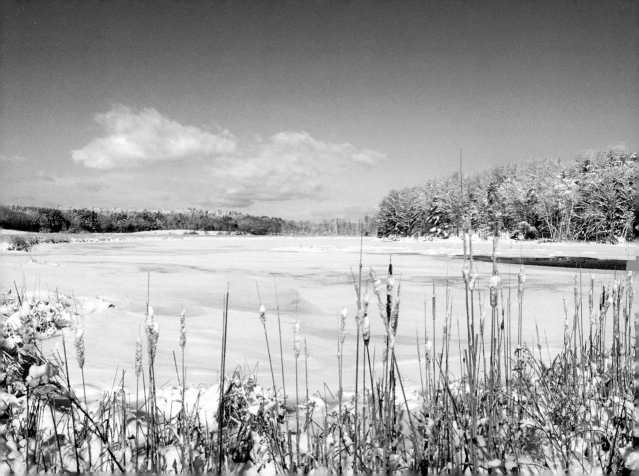

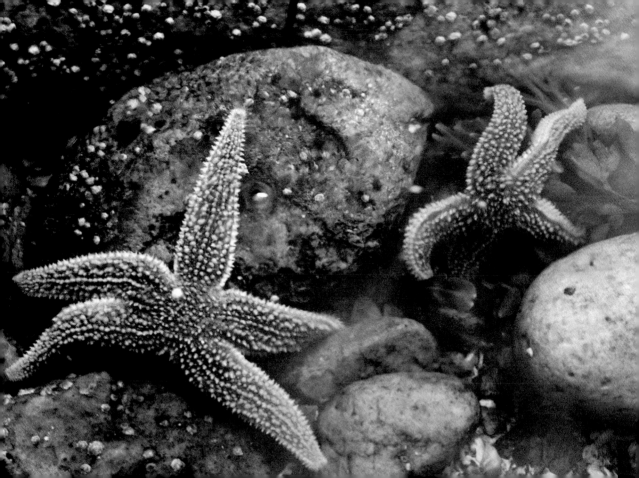

Acadia and Mount Desert Island

Mount Desert Island, Isle au Haut, the Schoodic Peninsula,

and Acadia National Park

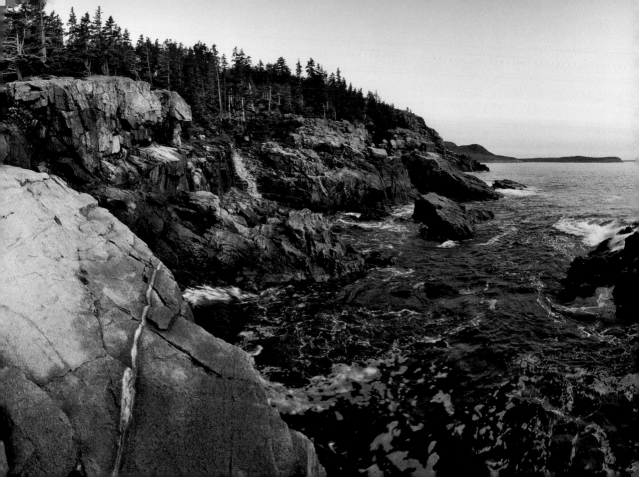

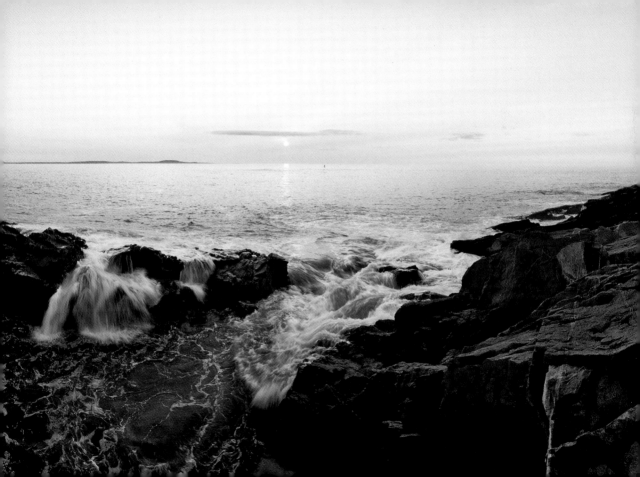

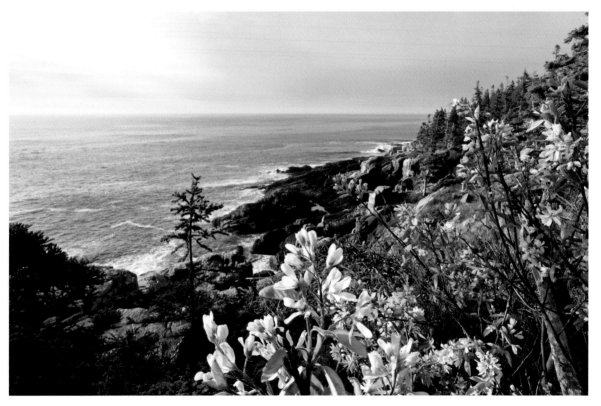

chapter opener *Starfish and barnacles in an Acadia National Park tidal pool* previous page *Sunrise along the dramatic shoreline at Otter Cliffs—at 110 feet, one of the highest coastal headlands north of Rio de Janeiro* above *Shadbush blooming in spring along the rocky Ocean Path south of Otter Cliffs* opposite *View to Otter Cliffs with mist rising from the ocean in the sub-zero winter air*

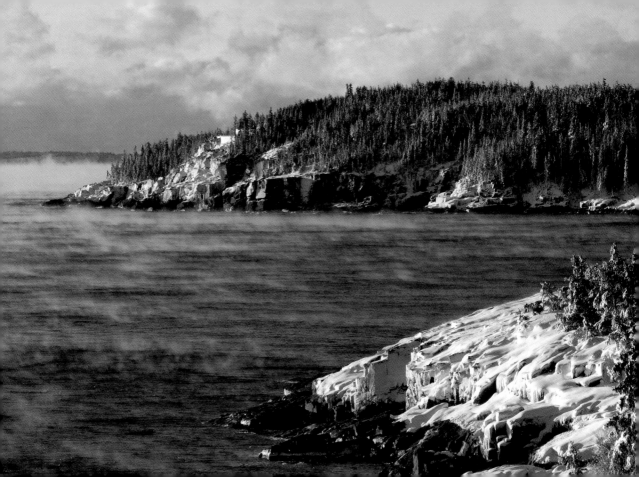

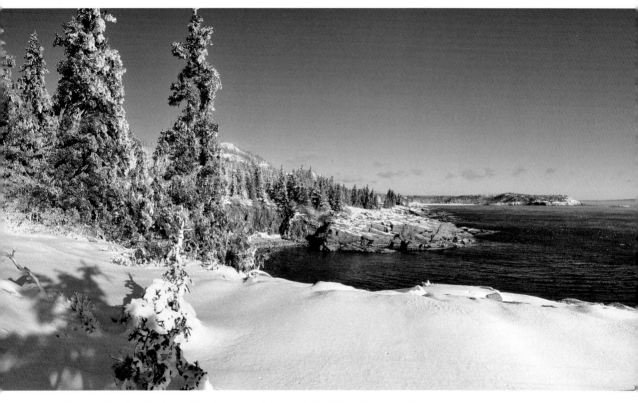

above *The coastline along the Ocean Drive becomes a winter wonderland after a January nor'easter*

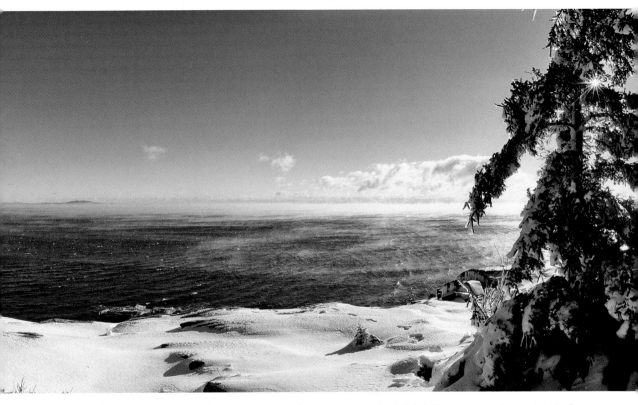

following page *The view from Penobscot Mountain encompasses Cadillac Mountain, South Bubble Mountain, Pemetic Mountain, Jordan Pond, and the Cranberry Isles in the Gulf of Maine*

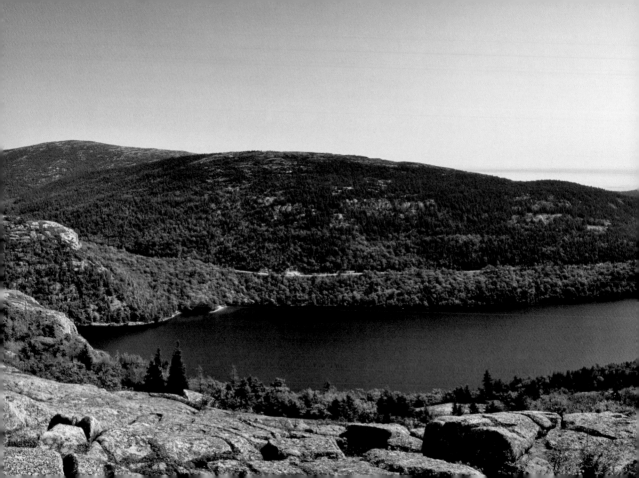

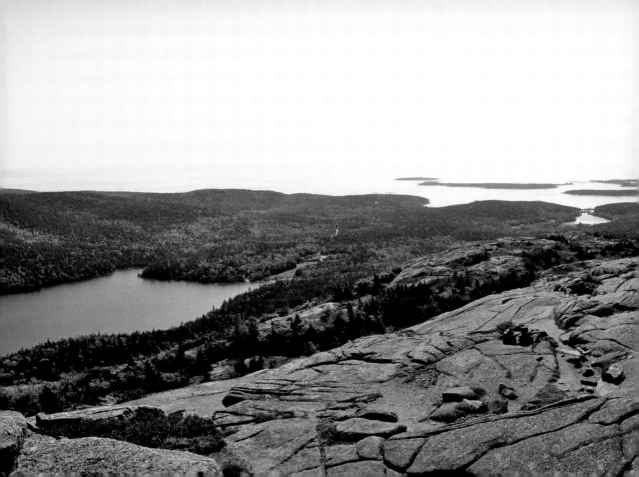

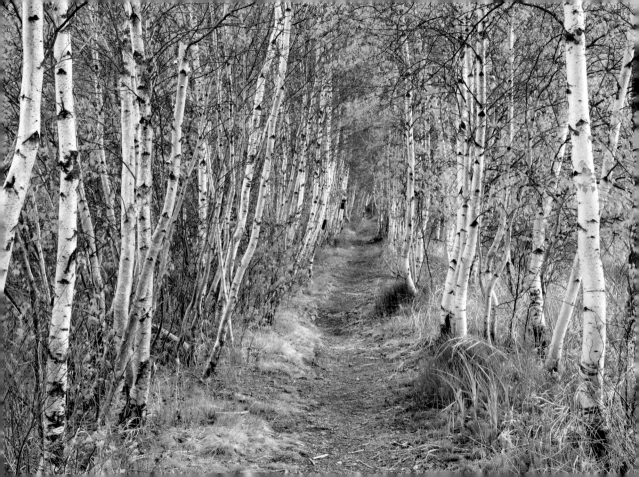

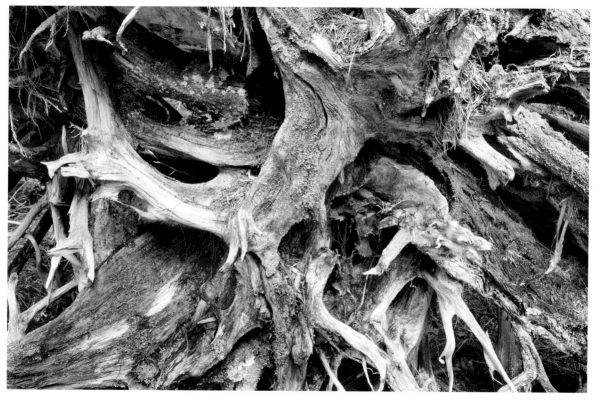

opposite *White birch line a National Park footpath near the Great Meadow*

above *Weathered roots along the trail in The Nature Conservancy's Indian Point Blagden Preserve*

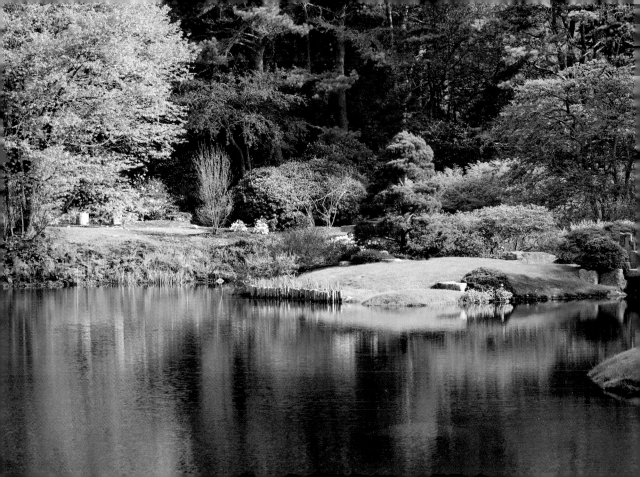

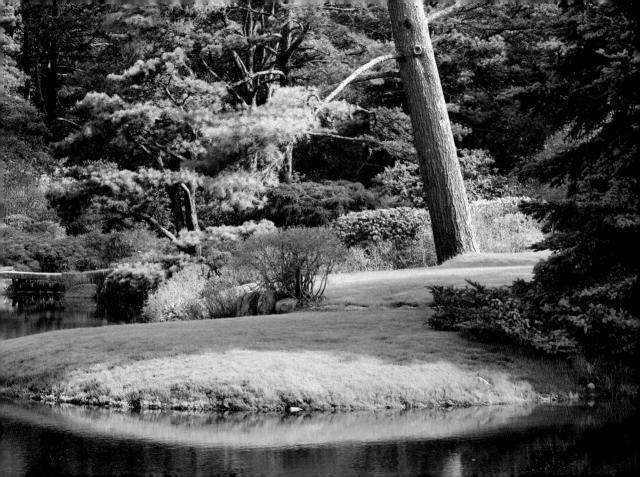

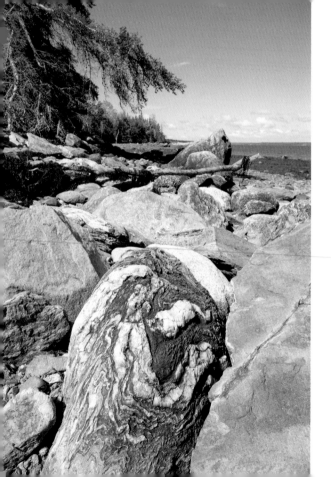

previous page *A quiet spring morning at Asticou Azalea Garden in Northeast Harbor*

left **Along Western Bay at the Indian Point Blagden Preserve**

opposite *Seals bask on the rocky islands in Long Cove at the Indian Point **Blagden** Preserve*

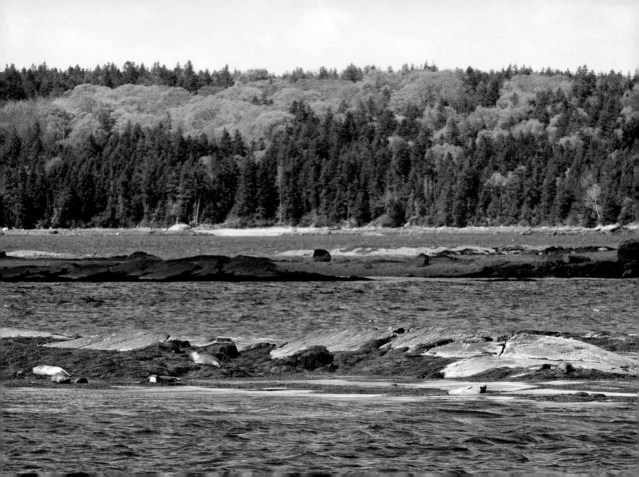

above *The rare orchid arethusa blooms in spring in a few select bogs on Isle au Haut*

opposite *Overlooking Western Bay from the Indian Point **Blagden** Preserve*

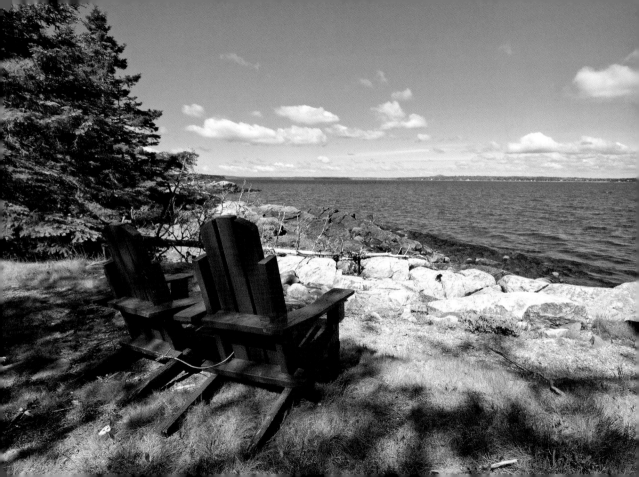

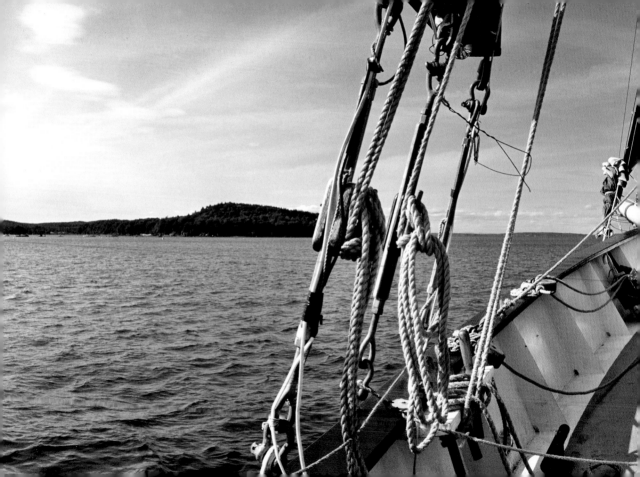

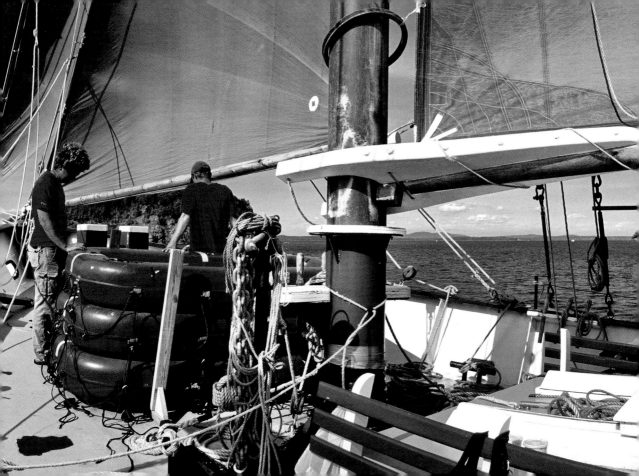

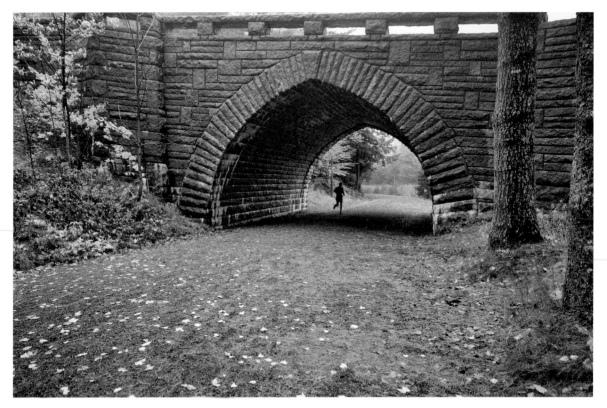

previous page *The steel-hulled, 151-foot, four-masted schooner the* Margaret Todd *sails regularly in season from Bar Harbor for a cruise on Frenchman Bay* above *A jogger runs under a carriage path bridge located at the north end of Eagle Lake* opposite *The Selectmen's Building (1780) arched bridge over the pond at the Somesville Historical Museum*

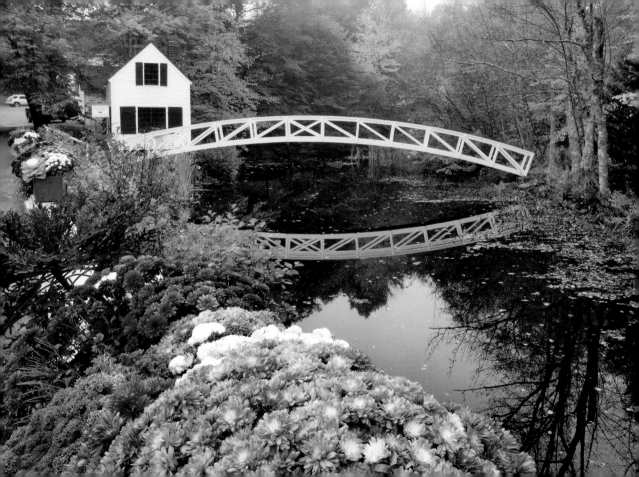

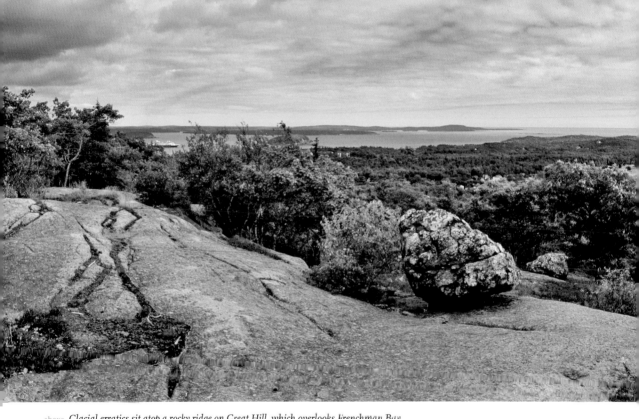

above *Glacial erratics sit atop a rocky ridge on Great Hill, which overlooks Frenchman Bay, Bar Harbor, Champlain Mountain, and Cadillac Mountain*

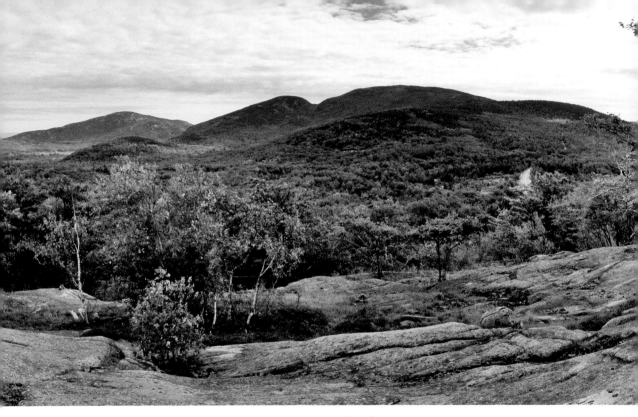

following page, left *Wave action potholes exposed at the base of Otter Cliffs at low tide*

following page, right *Mussel shells along the shoreline of Duck Harbor on Isle au Haut*

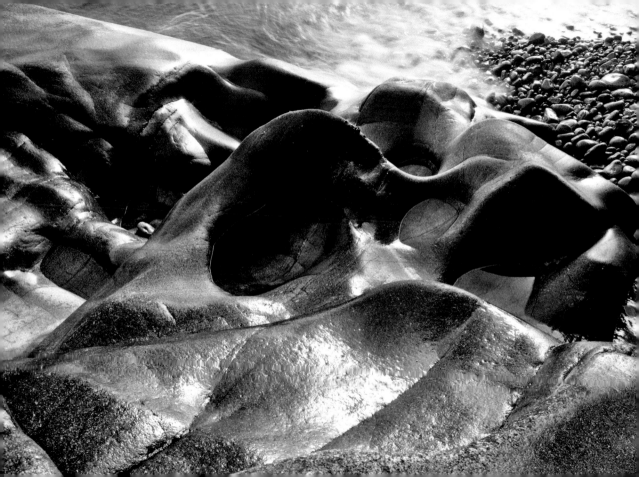

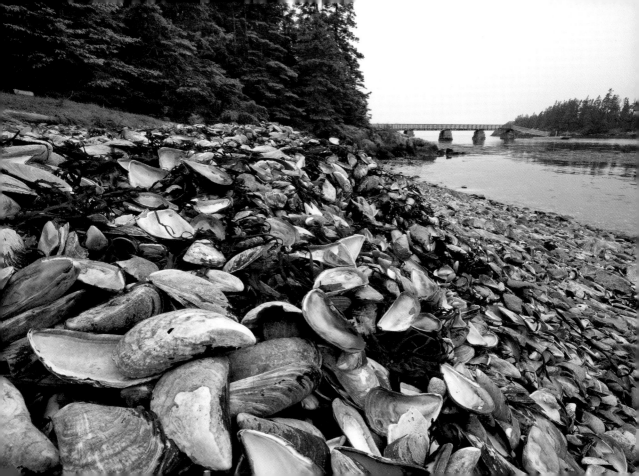

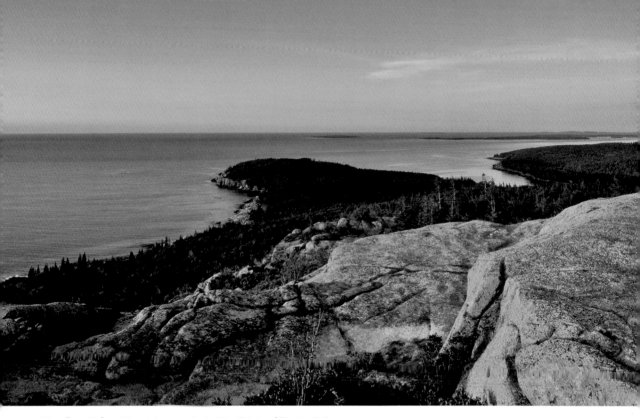

View from Gorham Mountain at sunrise to Otter Point and Western Point

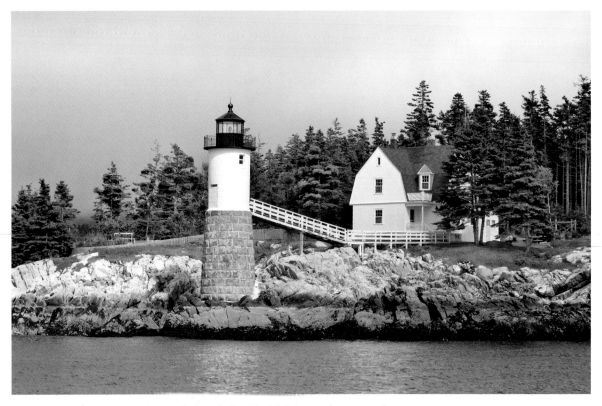

above *Isle au Haut, in 1907 this was the last cylindrical brick lighthouse to be constructed in Maine*

opposite *View from Acadia National Park's Cliff Trail on the southern end of Isle au Haut*

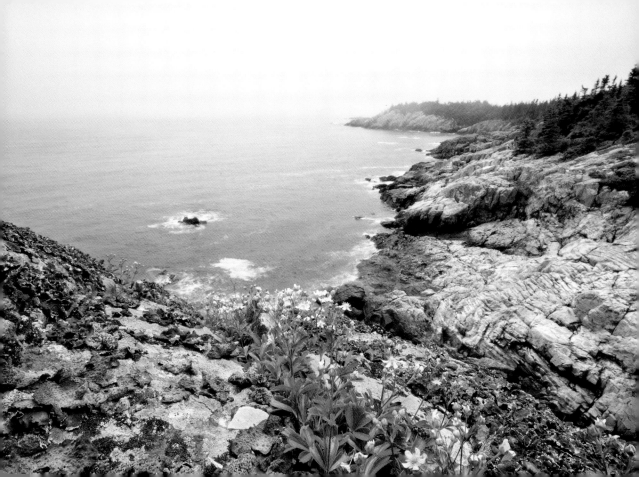

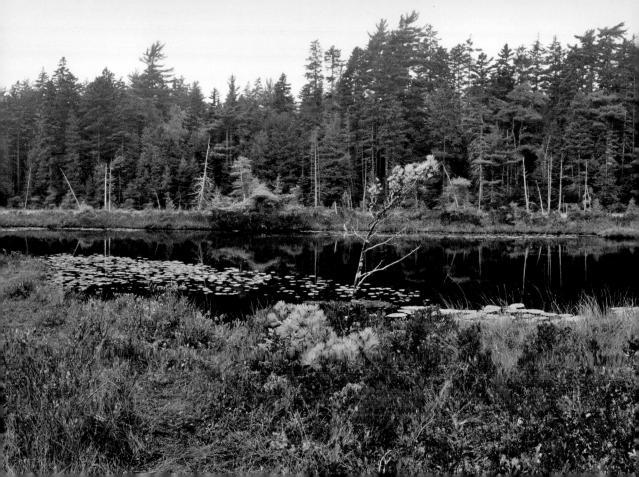

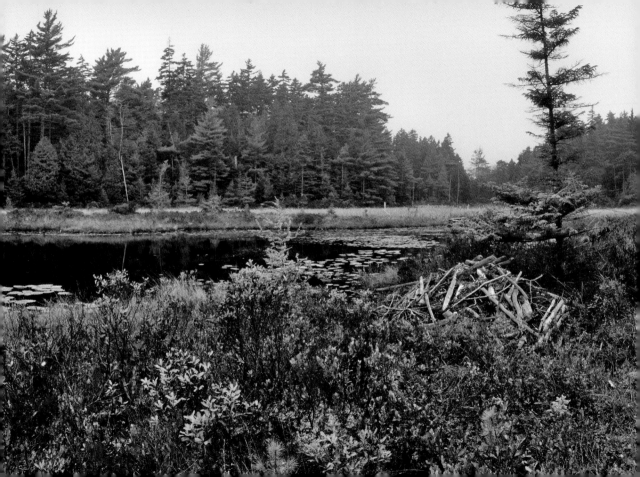

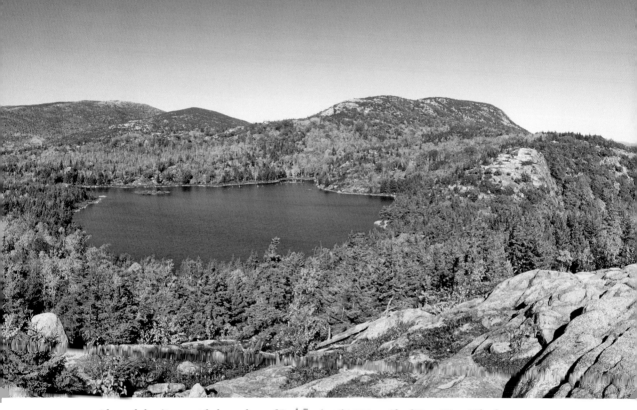

previous page *A beaver lodge sits among the boggy shores of Duck Pond on the western side of Mount Desert Island*

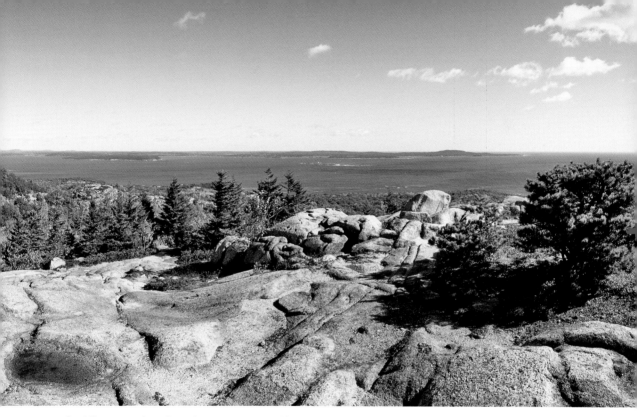

above *This fall panorama from The Beehive encompasses Cadillac Mountain, Dorr Mountain, Champlain Mountain, The Bowl, Frenchman Bay, and the Schoodic Peninsula*

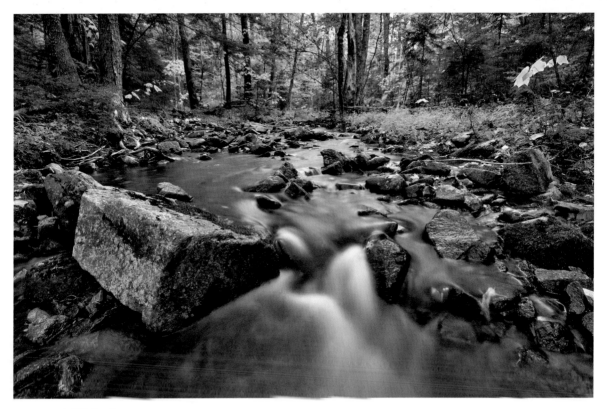

above *Bubble Brook*
opposite *Evening twilight at Bubble Pond*

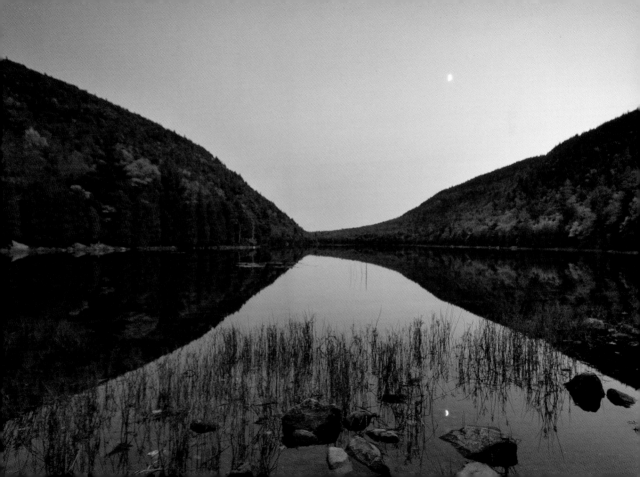

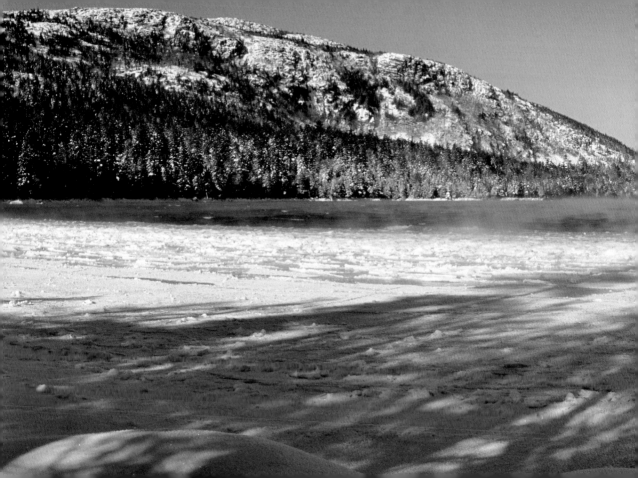

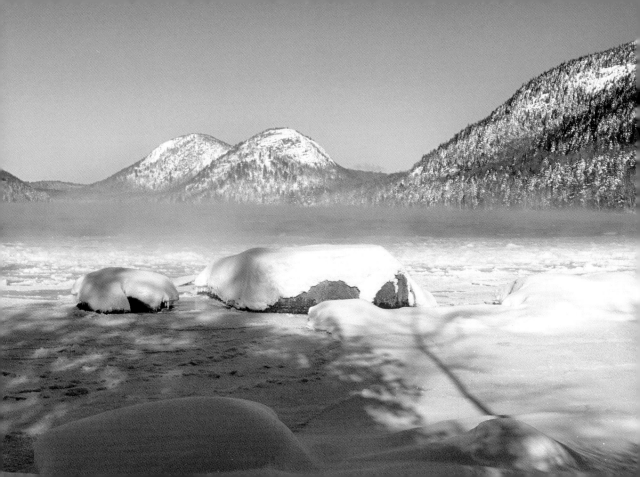

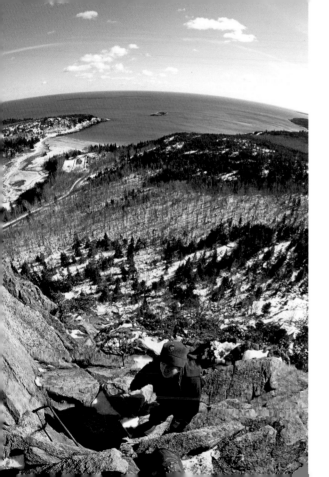

previous page *A bitter January wind blows mist across Jordan Pond while frazil ice builds up along the shore*
left *Sand Beach, Great Head, and Otter Cliffs from the trail near the top of The Beehive*
opposite *Great Head from the cliffs just south of the Sand Beach area*

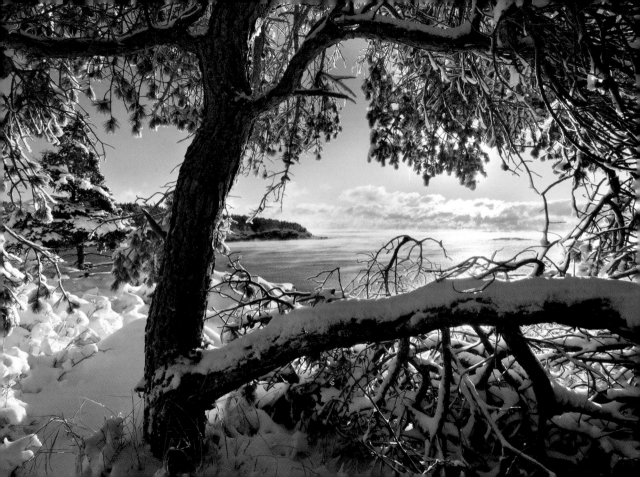

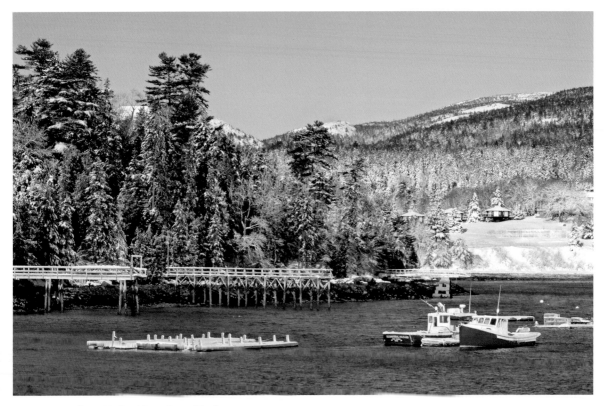

above *Northeast Harbor, Mount Desert Island*

opposite *The Sound School House Museum on Mount Desert Island*

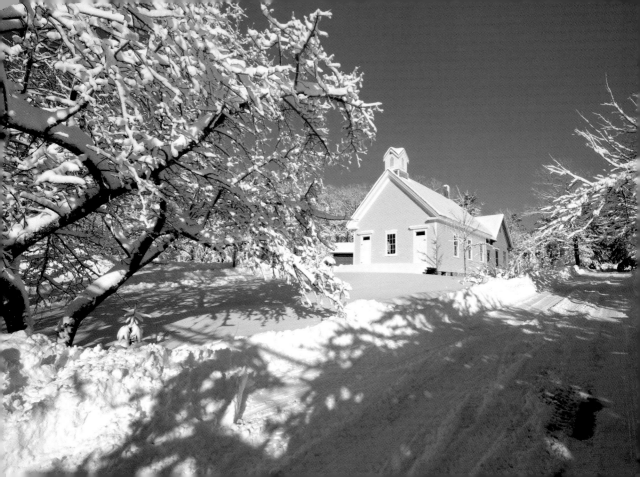

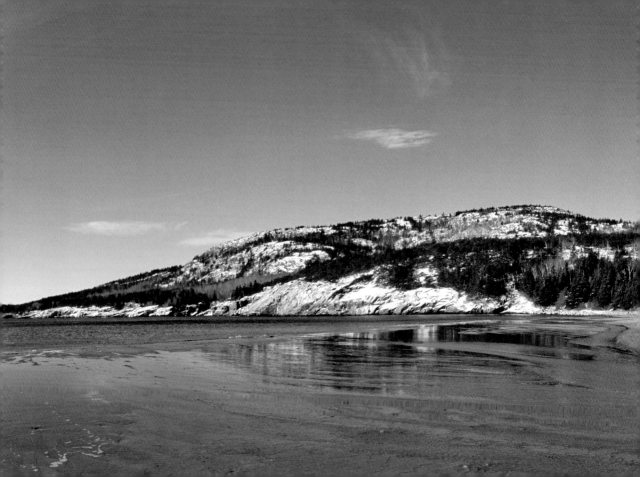

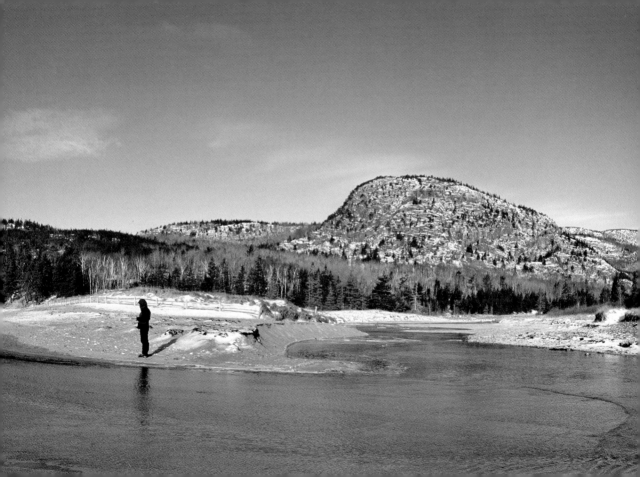

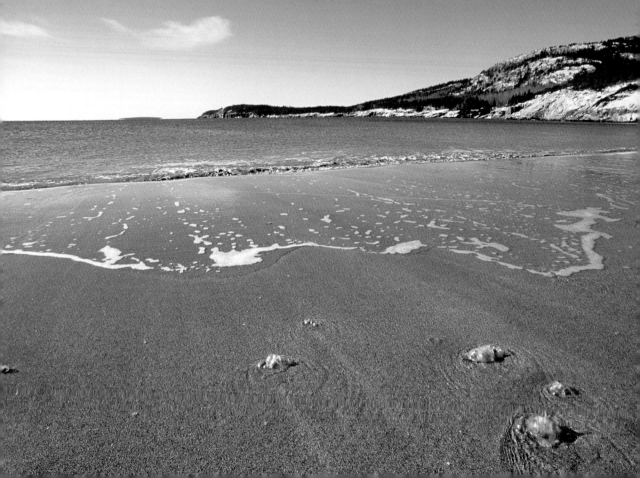

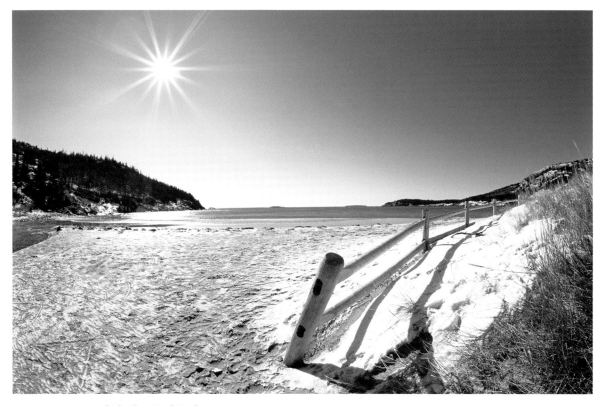

previous page *A wintry high tide at Sand Beach*
opposite *Sand Beach, bubbles rising from the sand at the edge of the surf*
above *A view of Great Head from the end of the protected dune*

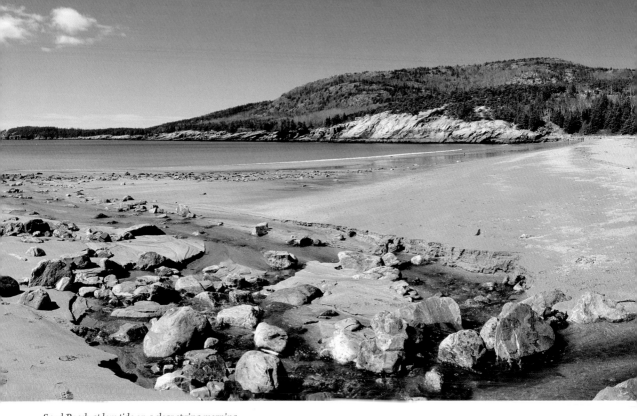

Sand Beach at low tide on a clear spring morning

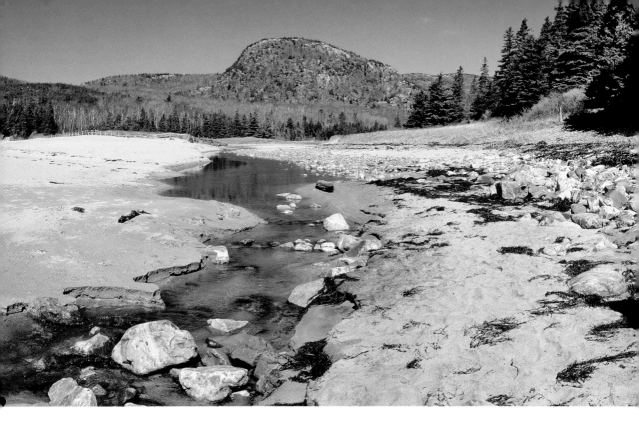

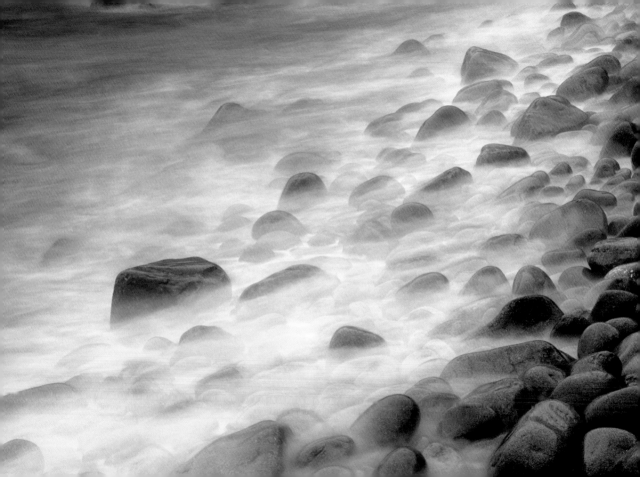

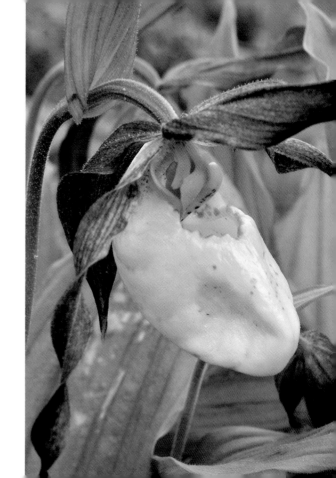

opposite *Waves filter through the cobblestones near Otter Cliffs*
right *A yellow lady slipper in bloom at the Wild Gardens of Acadia*
following page *A frozen shoreline by Pond Island on the
Schoodic Peninsula*

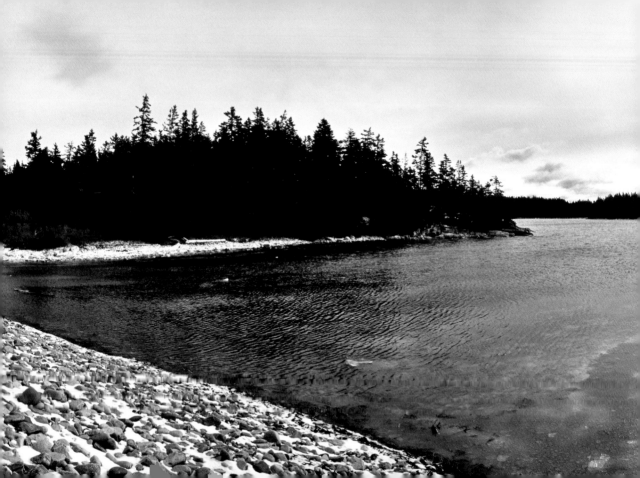

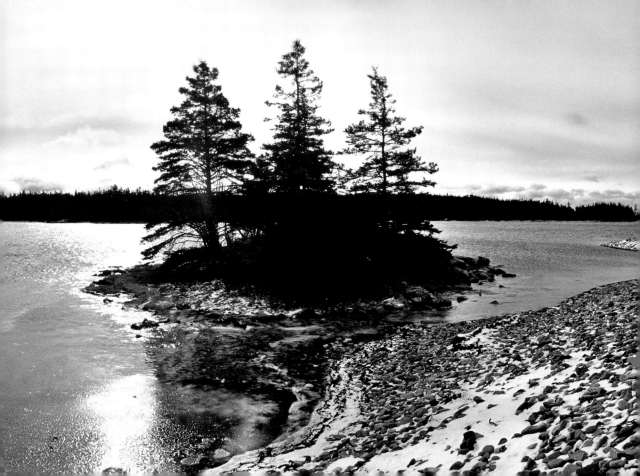

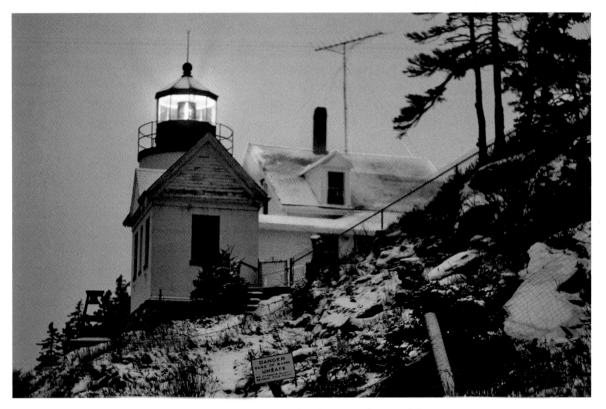

above *The Bass Harbor Head Lighthouse* opposite *Sunrise over the Atlantic from the Otter Cliffs area*
following page, left *Mount Desert Island seen through the wings of a biplane*
following page, right *Shadbush blossoms along the Mount Desert Island shoreline north of Bar Harbor*

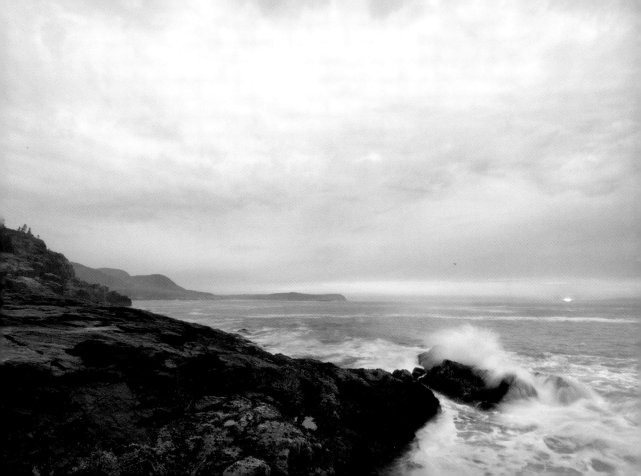

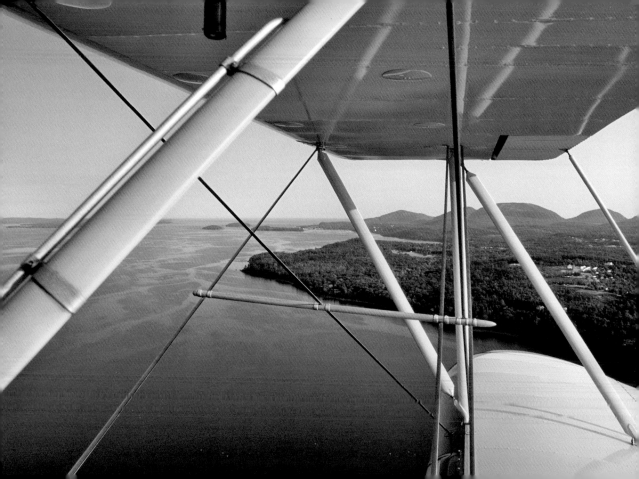

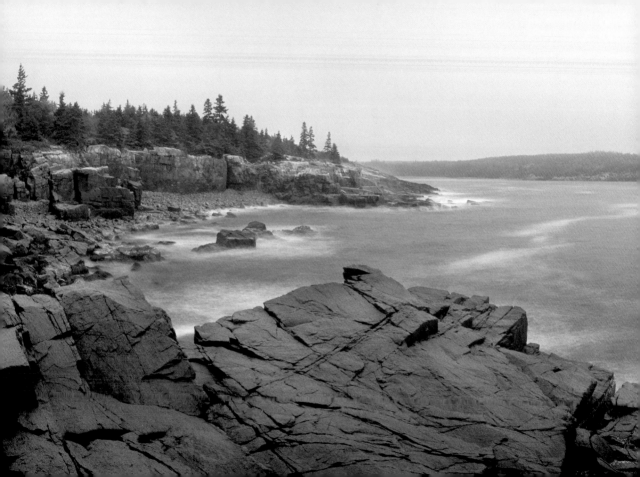

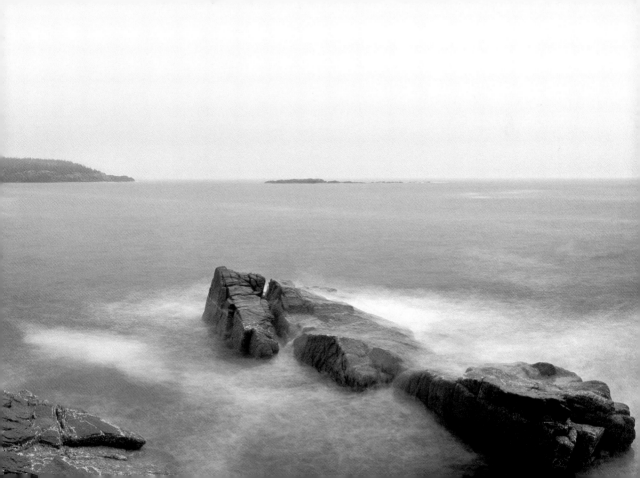

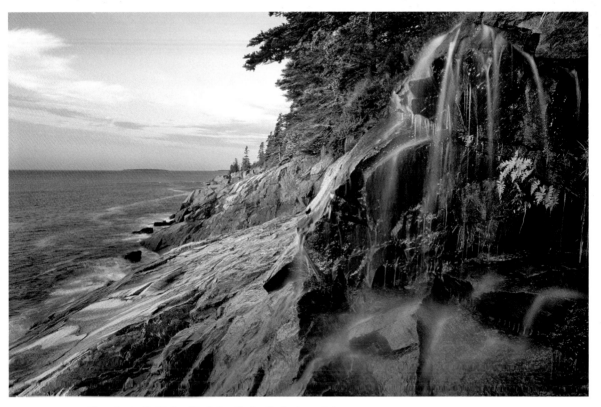

previous page *The rocky Acadia National Park shoreline beside the Ocean Drive*

above *A small cascade tumbles down the cliffs to the ocean near the Blackwoods Campground*

opposite *Spiny sea urchins and mussels thrive in the protected corner of a tidal pool on the shore of Isle au Haut*

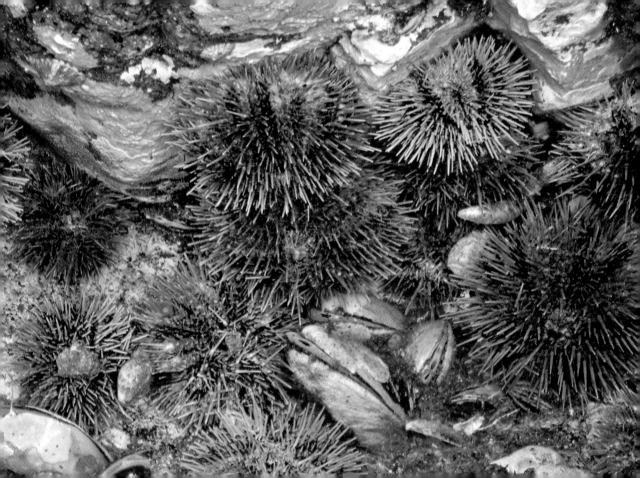

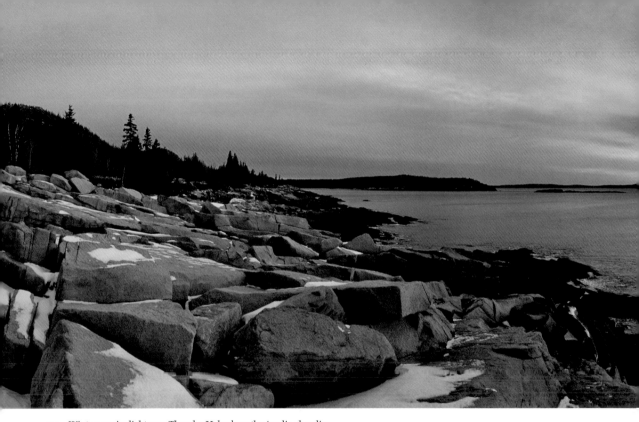

above *Winter sunrise light near Thunder Hole along the Acadia shoreline*

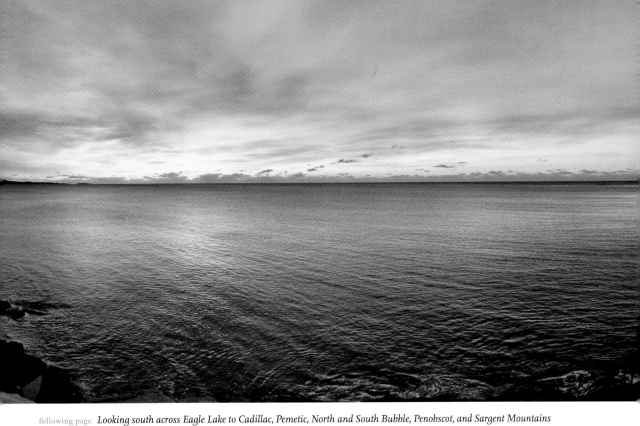

following page *Looking south across Eagle Lake to Cadillac, Pemetic, North and South Bubble, Penobscot, and Sargent Mountains*

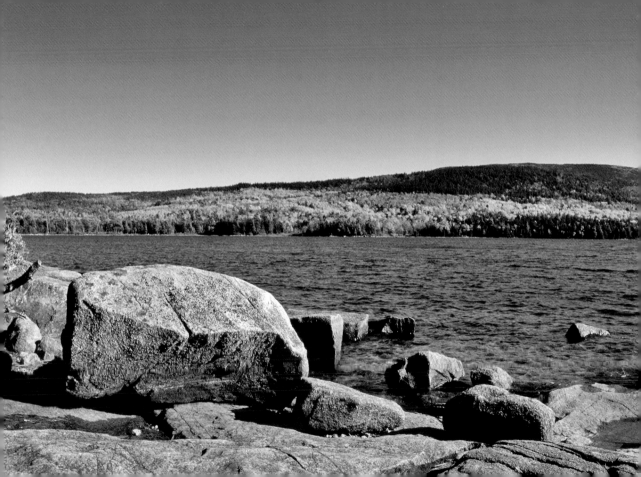

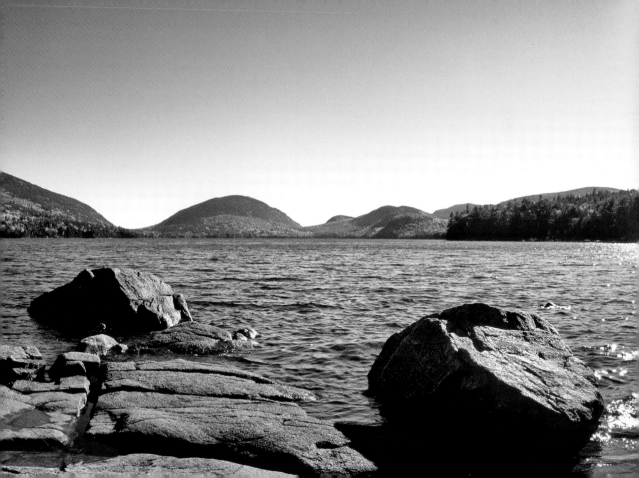

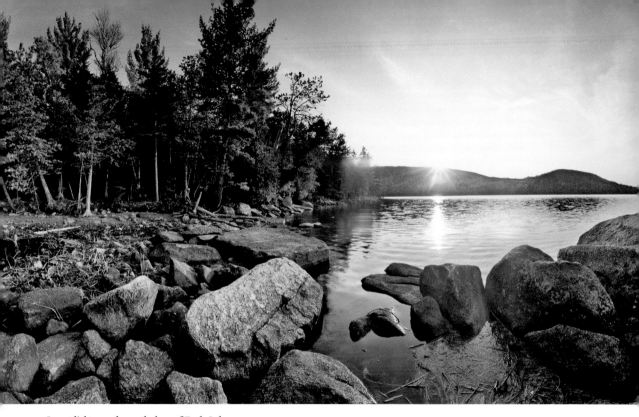

Sunset light over the south shore of Eagle Lake

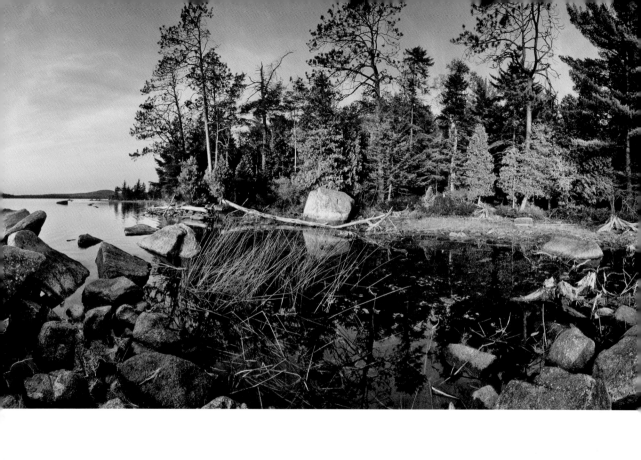

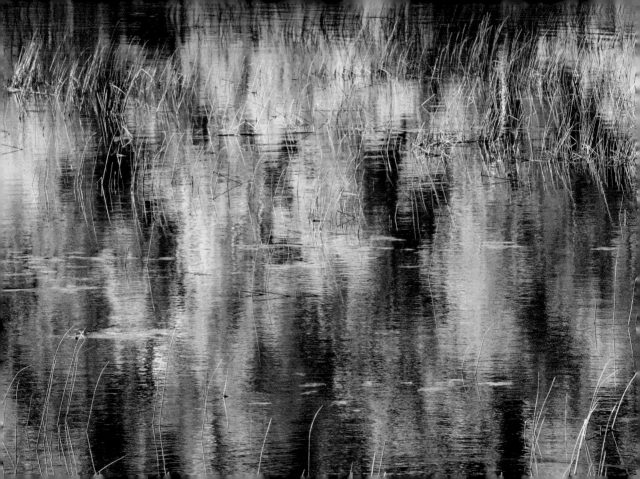

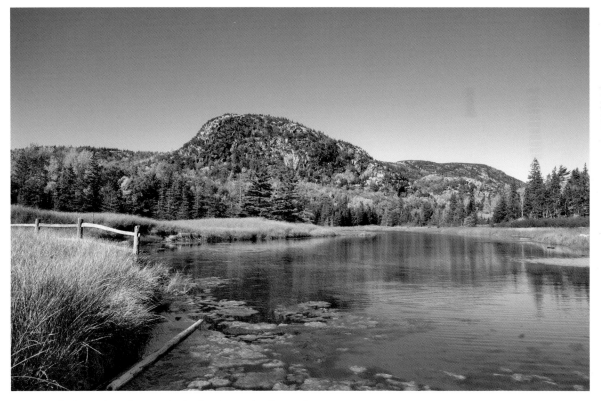

opposite *Reflections and marsh grasses in The Tarn, just south of Bar Harbor*
above *The Beehive reflecting in the brackish waters behind the dune at Sand Beach*

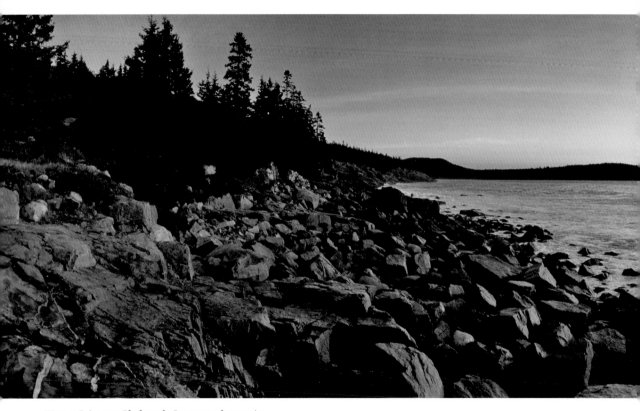

Western Point near Blackwoods Campground at sunrise

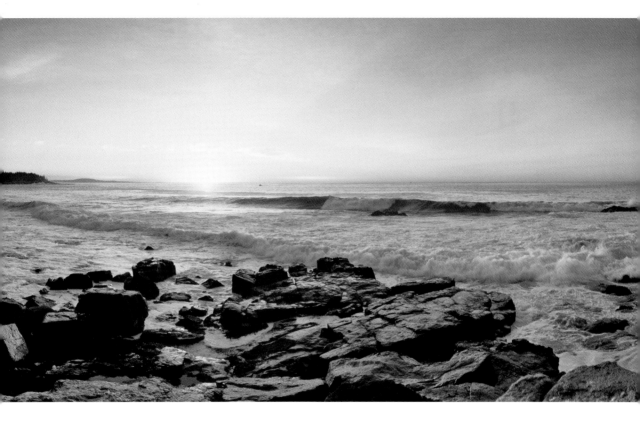

Down East Maine

✦❧❦❧✦

Castine, Stonington, Blue Hill Falls, Harrington, Jonesport,

Machias, Cutler, the Bold Coast, Lubec,

and Quoddy Head State Park

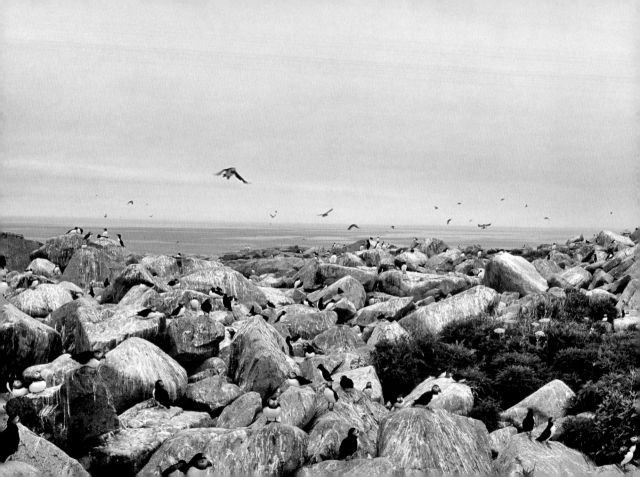

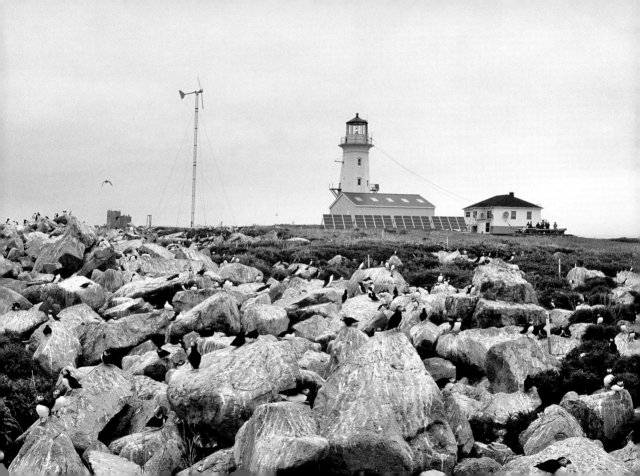

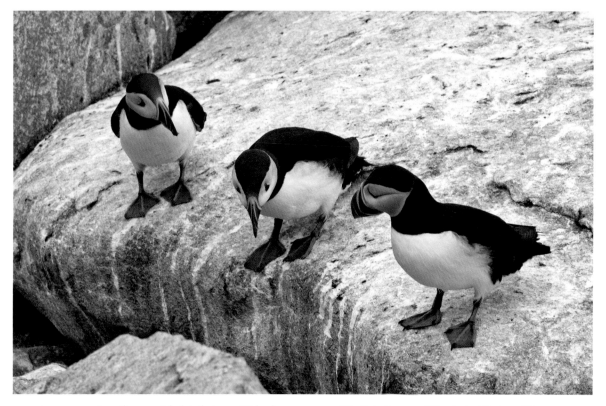

chapter opener *A weathervane at dusk in the town of Orland* previous page *Atlantic puffins, razorbills, viewing blinds, and the lighthouse and keeper's house at Machias Seal Island* above *Three Atlantic puffins watching another heading to her nest deep in the rocks* opposite *There is constant energy among all the nesting auks on the island*

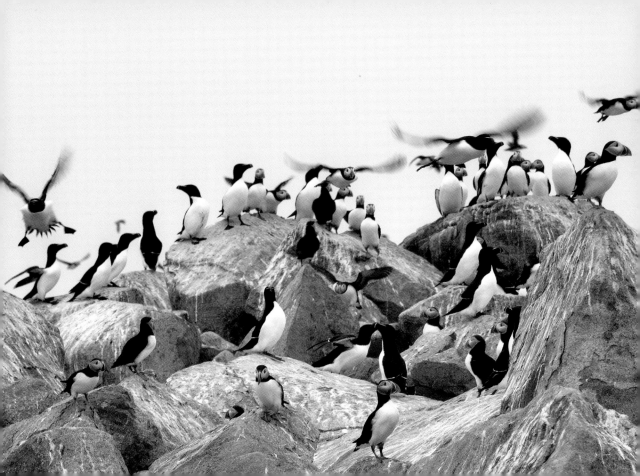

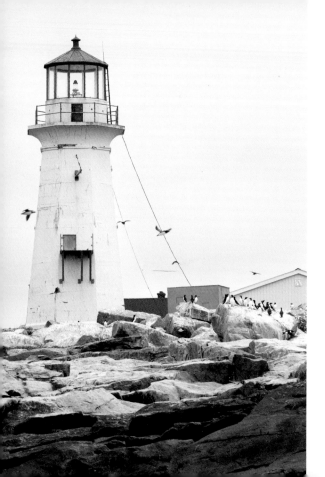

left *Puffins and razorbills flying around the Machias Seal Island Lighthouse*

opposite *Grey seals and a harbor seal at low tide on a small nearby island*

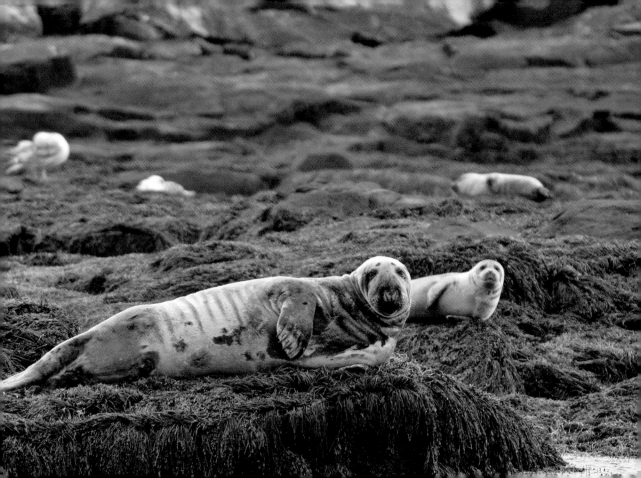

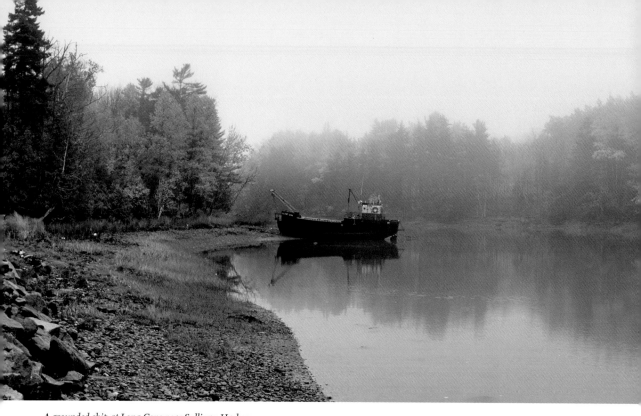

A grounded ship at Long Cove near Sullivan Harbor

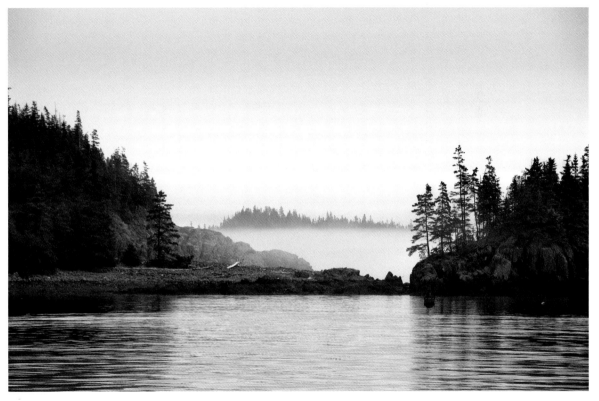

opposite *Mist and fall foliage at Taunton Bay near West Sullivan*
above *The mist-draped Bold Coast at the entrance to Cutler Harbor*

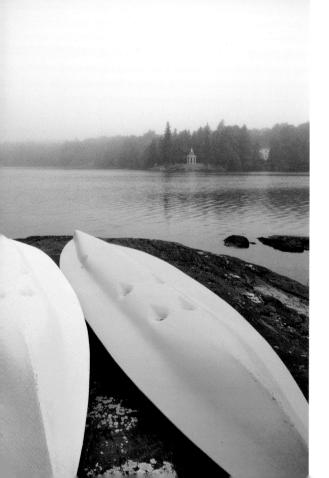

left *Kayaks by the pond at The Pilgrim's Inn, Deer Isle*
opposite *Daisies, lupines, and wild roses in the meadow by the Inn*

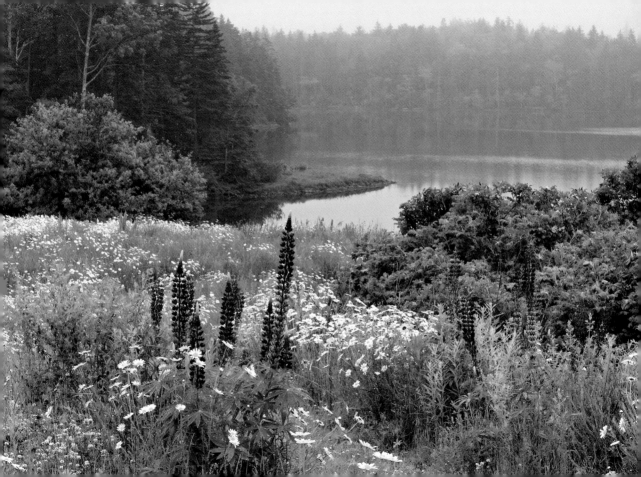

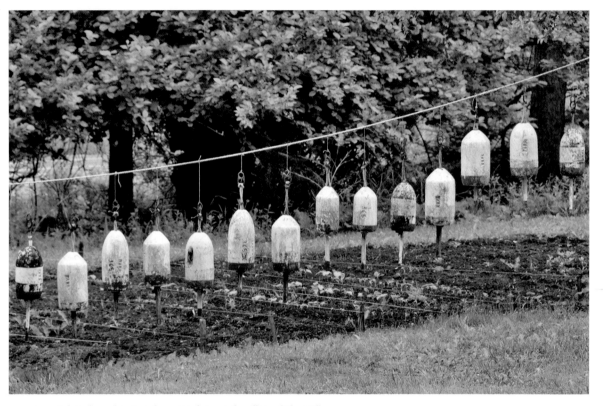

above *Lobster buoys hanging above a garden near the village of Blue Hill*
opposite *Moored boats in Naskeag Harbor at the WoodenBoat School, Brooklin*

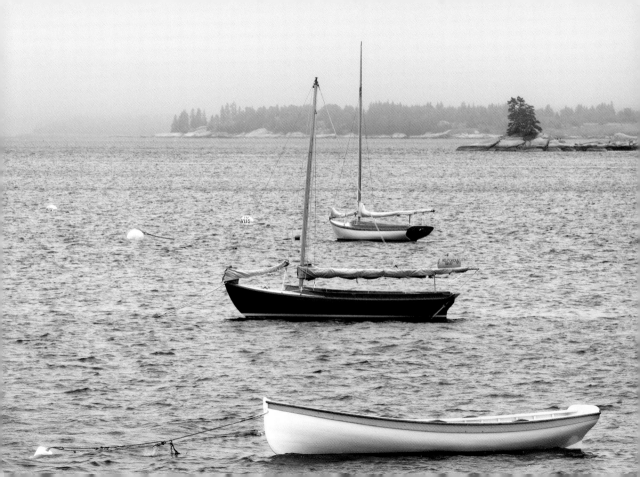

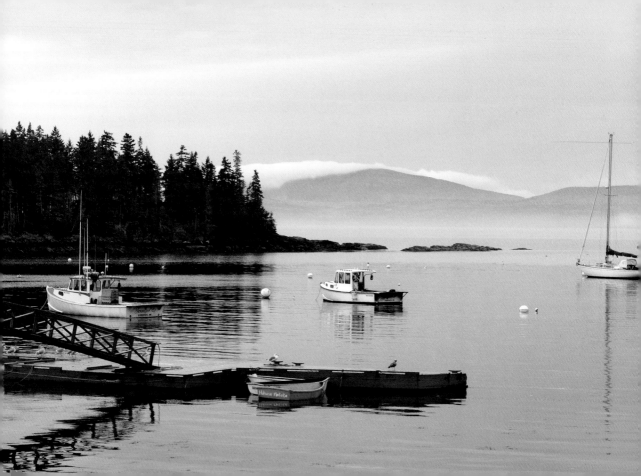

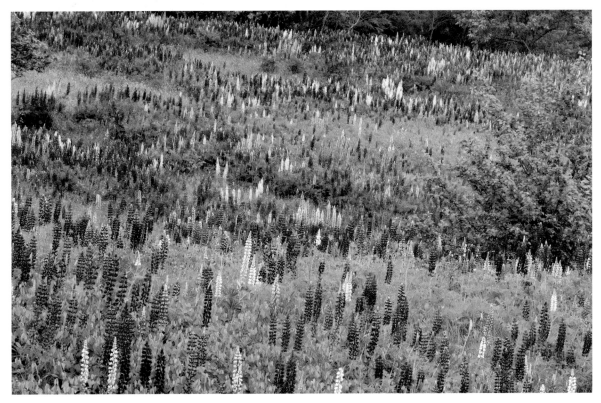

opposite *Looking east across Sorrento Harbor*

above *Lupines blooming near the end of June in a field along Highway 1A near Harrington*

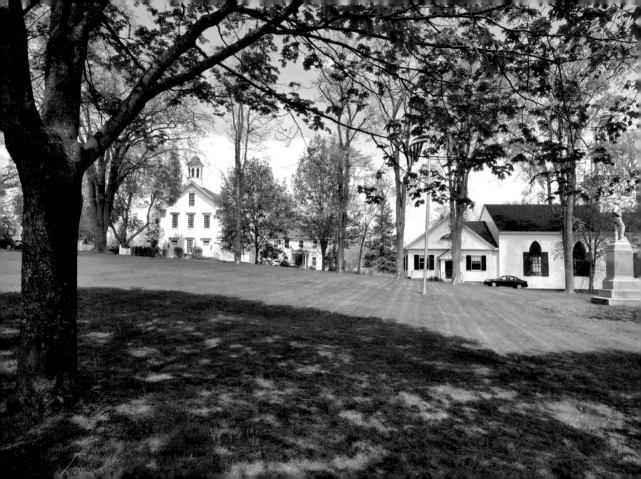

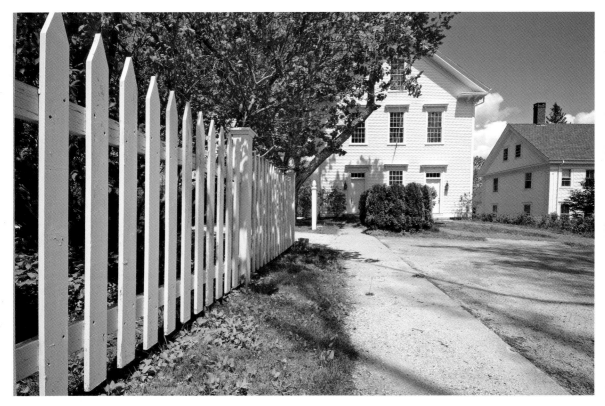

opposite *Castine, the historic town green*

above *Looking along a picket fence to the 1859 Abbott School building*

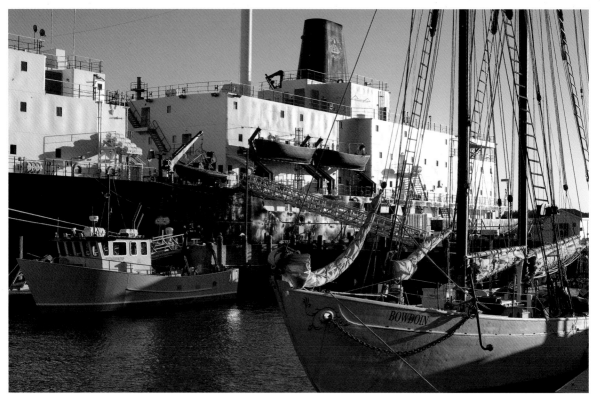

above *The* Bowdoin, *built in 1920–21 and capable of sailing in Arctic waters, is docked next to the research vessel the* T.S. State of Maine. *Both are ships of the Maine Maritime Academy*

opposite *Sailing in the Bagaduce River beyond Castine Harbor*

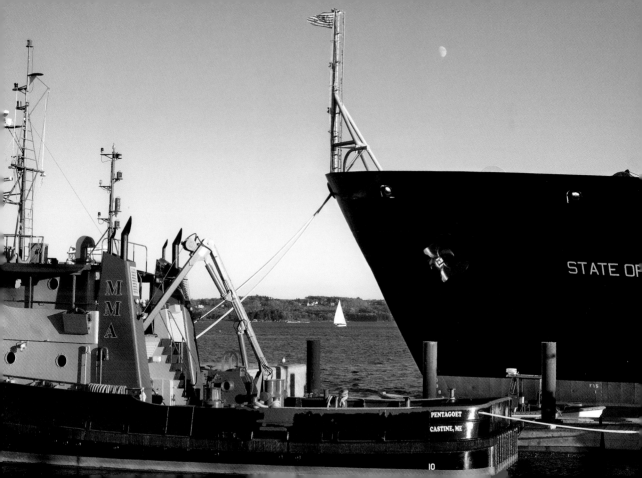

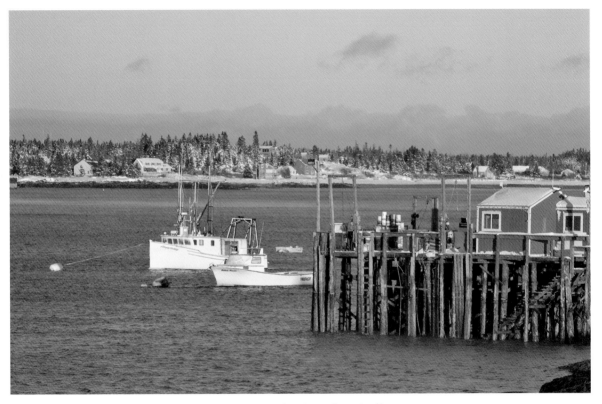

above *A snowy view across Moosabec Reach to Jonesport from the fishing village of Beals*

opposite *The Jonesport Packing Company processed sardines from 1936–63.*

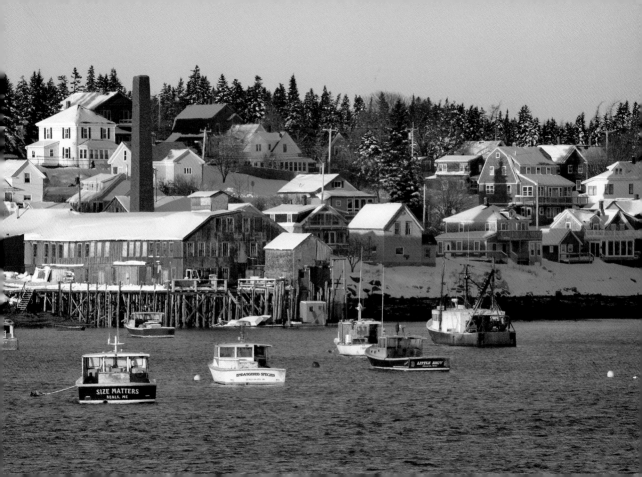

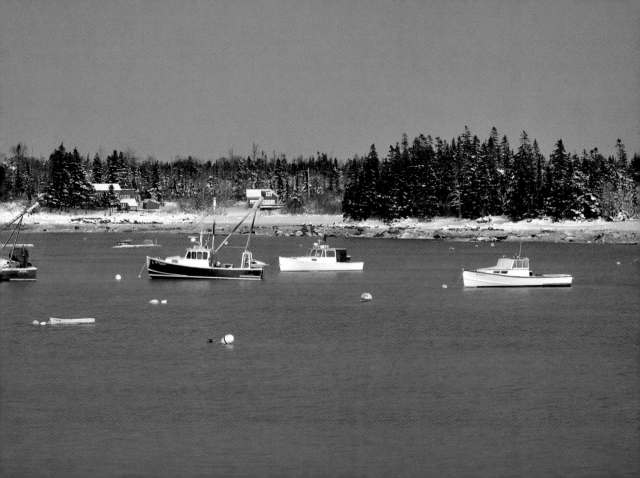

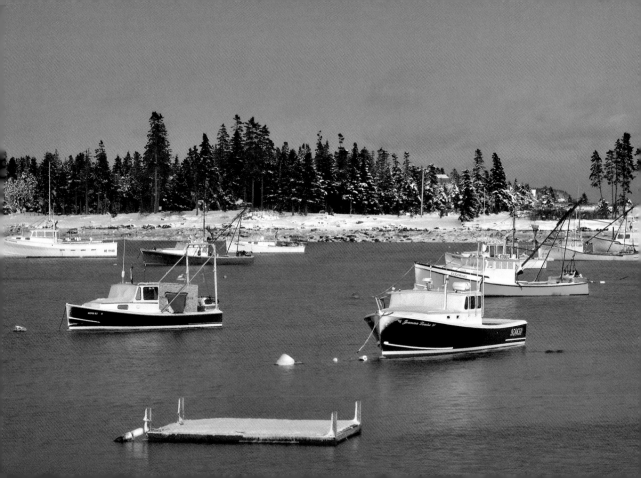

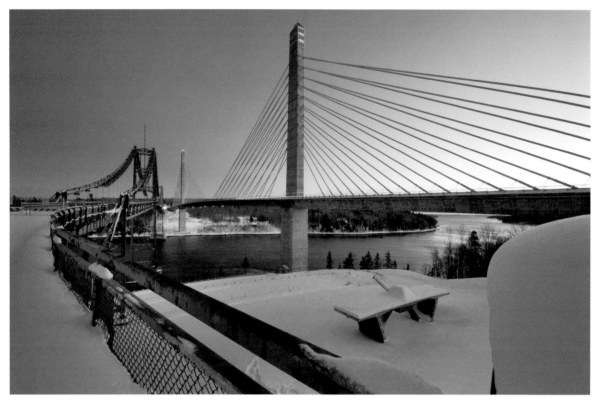

previous page *Evening twilight in Jonesport Harbor*

above *The Penobscot Narrows Bridge at Bucksport is the coastal gateway to Down East Maine*

opposite *A misty evening at Stonington Harbor*

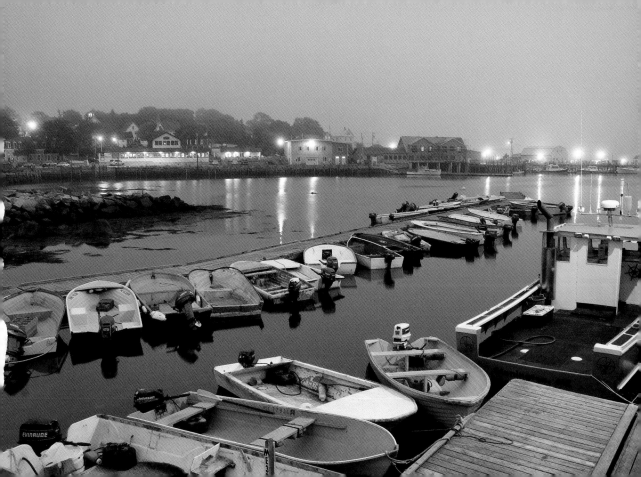

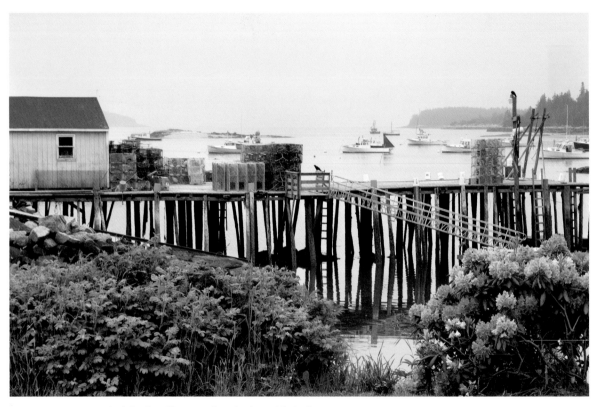

above *Stonington, rhododendrons blooming along the shore of the harbor*

opposite *A dinghy at low tide among the granite shores and village homes*

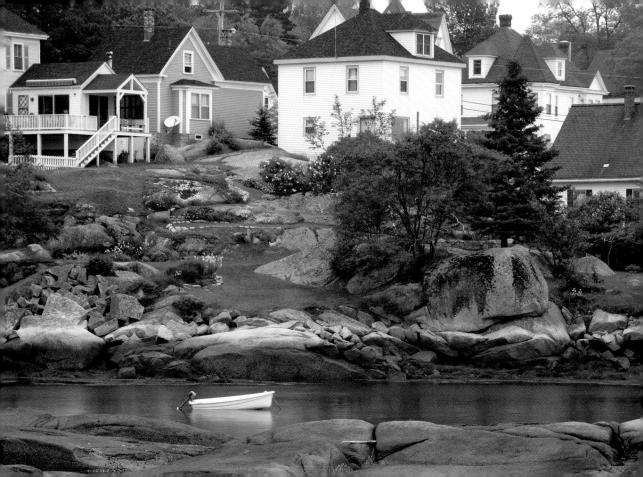

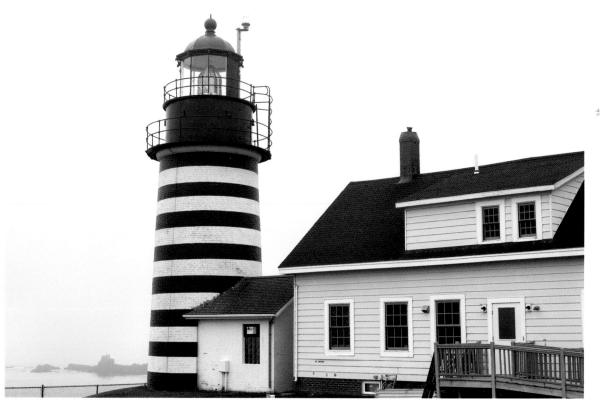

above *The West Quoddy Head Light (1857) is the only candy-striped lighthouse in New England*

opposite *Jagged offshore rocks at Quoddy Head State Park*

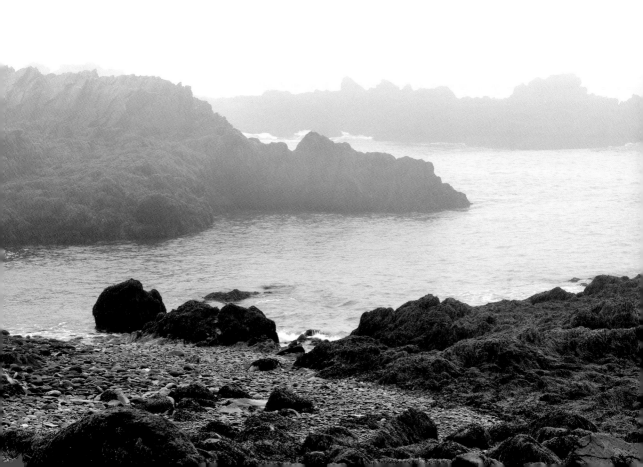

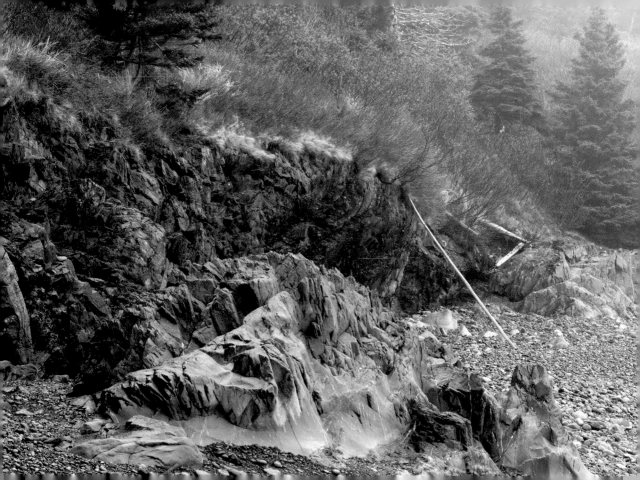

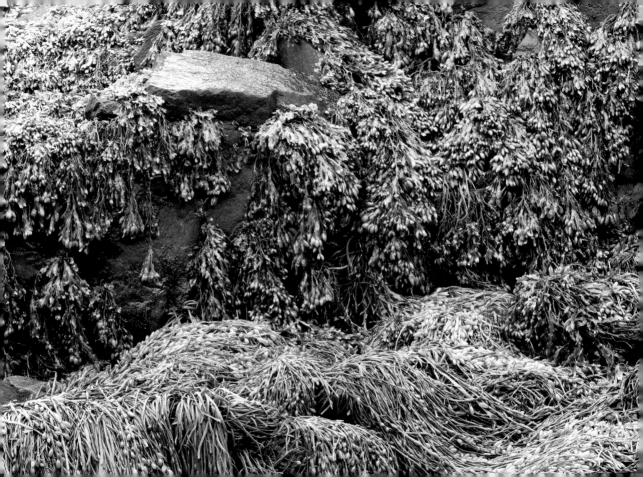

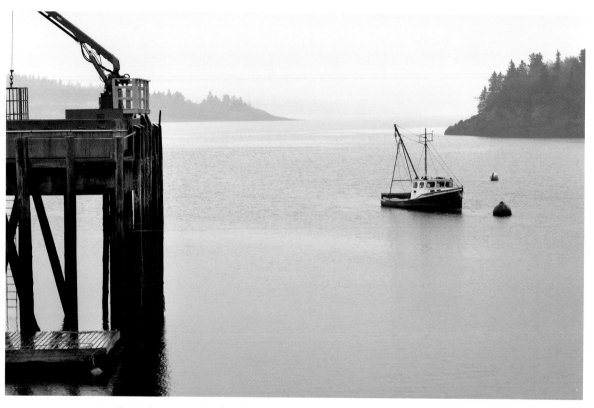

previous page, left *Quoddy Head State Park, shoreline detail at the easternmost point of land in the continental United States*
previous page, right *Rockweed covers all of the larger rocks in the intertidal zone* above *Lubec, on the Cobscook Bay, is affected by the Bay of Fundy and experiences about an 18-feet difference in the tides* opposite *Digging for clams at low tide in the sand flats near Lubec*

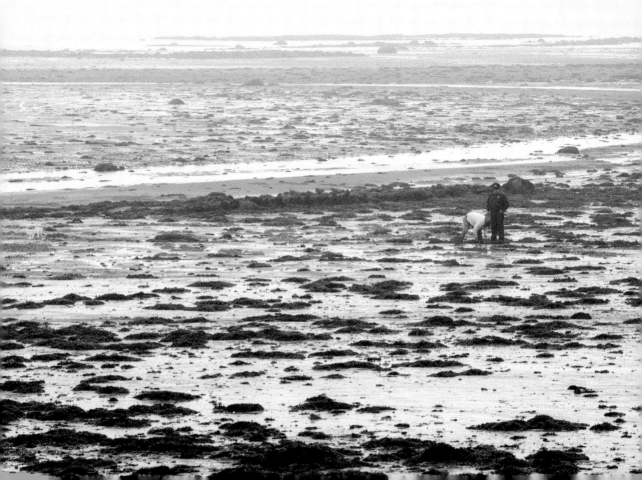

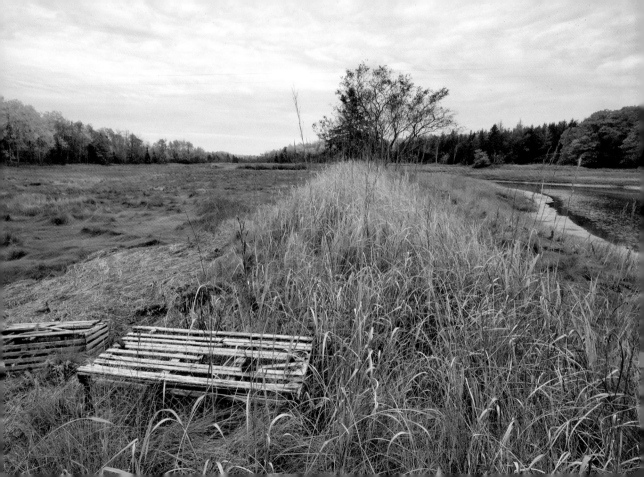

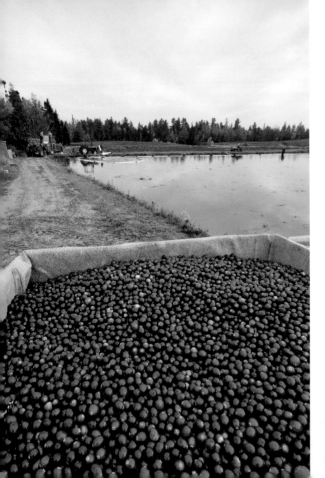

previous page, left *Tidal marsh along the Mill River in West Harrington*
previous page, right *Blueberry barrens are a common sight along back roads in Down East Maine*
left **After the harvest, West Harrington**
right *Tightening the boom to concentrate the berries for collection*
following page *A pair of flooded cranberry bogs reflect the colors of sunset*

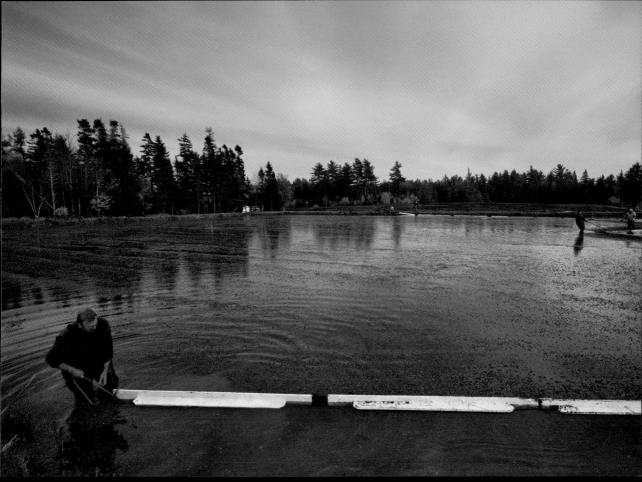

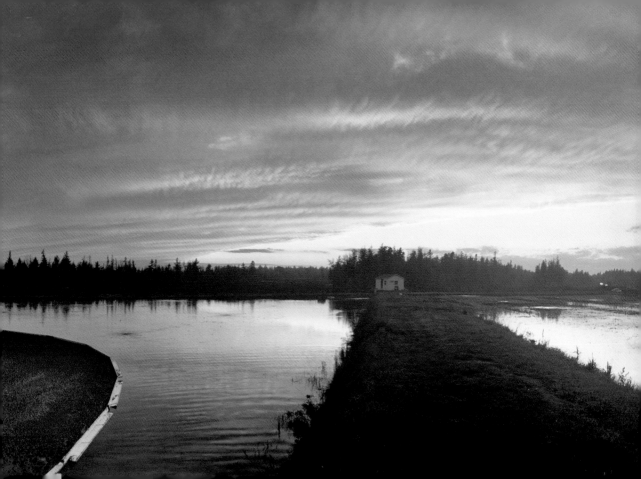

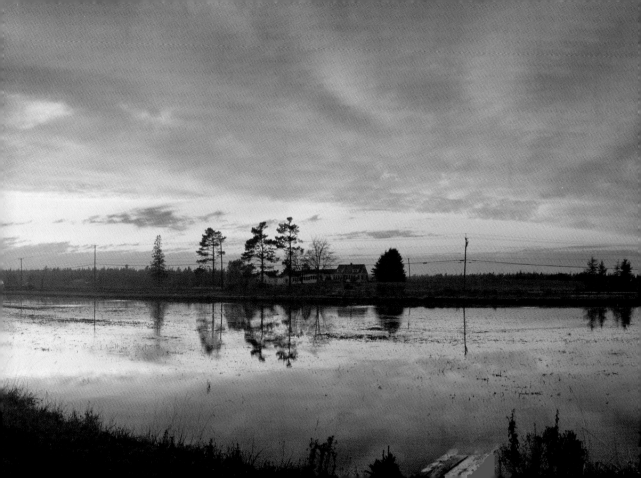

Acknowledgments

I would especially like to thank Christopher Steighner and Charles Miers of Rizzoli for once again giving me the opportunity to work with them on another great book. I have enjoyed working directly with Chris and his fine editorial skills and attention to detail. I have appreciated working again with Sara Stemen and her skills at creating a finely crafted book from a diverse collection of photographs and text. I would like to thank Nancy Sferra of The Nature Conservancy in Brunswick, folks at the Boothbay Region Land Trust, Laura Sewall and Bates College, Margaret Hoffman of the Coastal Maine Botanical Gardens, and Ginger Currens of the Desert of Maine for their help in finding some of the photo locations. Thanks much to Bob Kline for going out of his way to help me do photography at the Pemaquid Point Light. Thanks much also to Steve Collins of Acadia Air Tours for helping with a biplane flight, and to the Hammond Family in West Harrington for allowing me to photograph during their annual cranberry harvest. Many thanks also to Captain Jack and his wife Barbara of the schooner *Surprise* in Camden, Captain Andrew Patterson and his expertise while leading the puffin tour, the crew of the schooner *Margaret Todd* in Bar Harbor, and Ronald Peabody of the Maine Coast Sardine History Museum in Jonesport for help with some caption details. I appreciated the services of the Casco Bay Lines and the Monhegan Boat Line, as well as the hospitality of the Pilgrim's Inn on Deer Isle, the Seaside Inn of Port Clyde, and the Riverside Inn in East Machias. Folks at both the Greater York Region Chamber of Commerce and the Boothbay Harbor Chamber of Commerce were quite helpful with suggestions for locations and timing. I would like to extend a big thank you to David Middleton and his detailed book, *The Photographer's Guide to the Maine Coast,* which helped immensely for photo locations. Many thanks also to the numerous friendly people in Maine who helped in different ways while I was photographing—from directions to suggestions (and even helping find lost equipment). Most of all I would like to thank my wife, Meg, for her unwavering support while I was pulling this book together, and for her companionship and willingness to go with the flow on the intense photo trips we took together. Many, many thanks once again to my daughter, Greta, for her expertise with Photoshop and skills in the office, which ensured this book could come together so smoothly—as well as for modeling for photos on a cold winter Acadia trip. And finally, a special thanks to my sister, Mary Alice, who braved some of the toughest winter weather Maine has to offer on our first trips to the wonderful coast of Maine.

First published in the United States of America in 2009 by Rizzoli International Publications, Inc.
300 Park Avenue South
New York, NY 10010
www.rizzoliusa.com

© 2009 Carl Heilman II

2012 2013 2014 2015 / 10 9 8 7 6 5 4 3

Distributed in the U.S. trade by Random House, New York

Design by Sara E. Stemen
Printed in China

ISBN: 978-0-8478-3205-7
Library of Congress Control Number: 20088937926